Altered Art

A colouring Book with Collage Capabilities

Coloured By

Illustrated by Melodye Whitaker

The Art of Collage

I love the look of "altered" book covers and mixed media canvases; whether they are painted, coloured, bejeweled, cut up or otherwise transformed. The technique of collage - which means "cut and paste" takes two dimensional art to another level. I use this technique on the computer to create my colouring pages by scanning hand drawn images and importing them to a program where I can clip and paste elements of drawings into a (hopefully) pleasing composition; layering the images to create the illusion of depth.

In Altered Art, you have two copies of each colouring page. You can colour both, trying different shades and colours or you can use the second set to collage the first. The collage technique is also a great way to self correct by using the second image to layer those parts of the image you want to change.

If you choose to collage, here are some tips:
First colour the elements you want to cut and paste.
Use a glue stick, glue dots, or thin double stick tape to paste.
If you use markers or pens, use a blank sheet behind each page.
You can cut out the element and trace it onto previously coloured papers, such as magazine pictures, old books, wrapping paper, etc.
Add metallic thread, jewels, buttons, feathers, torn paper, etc. - Whatever you keep in your treasure box might be just perfect!

At the end of the first section you will find a cake to decorate to try your hand at collage. Above all have fun, be creative, add your words, and colour outside the lines! Thanks! Melodye

For examples of collage art, follow me on pinterest.com/melodyerwhitaker. Post your finish work to Steampunk Fantasies and Altered Art on facebook.com

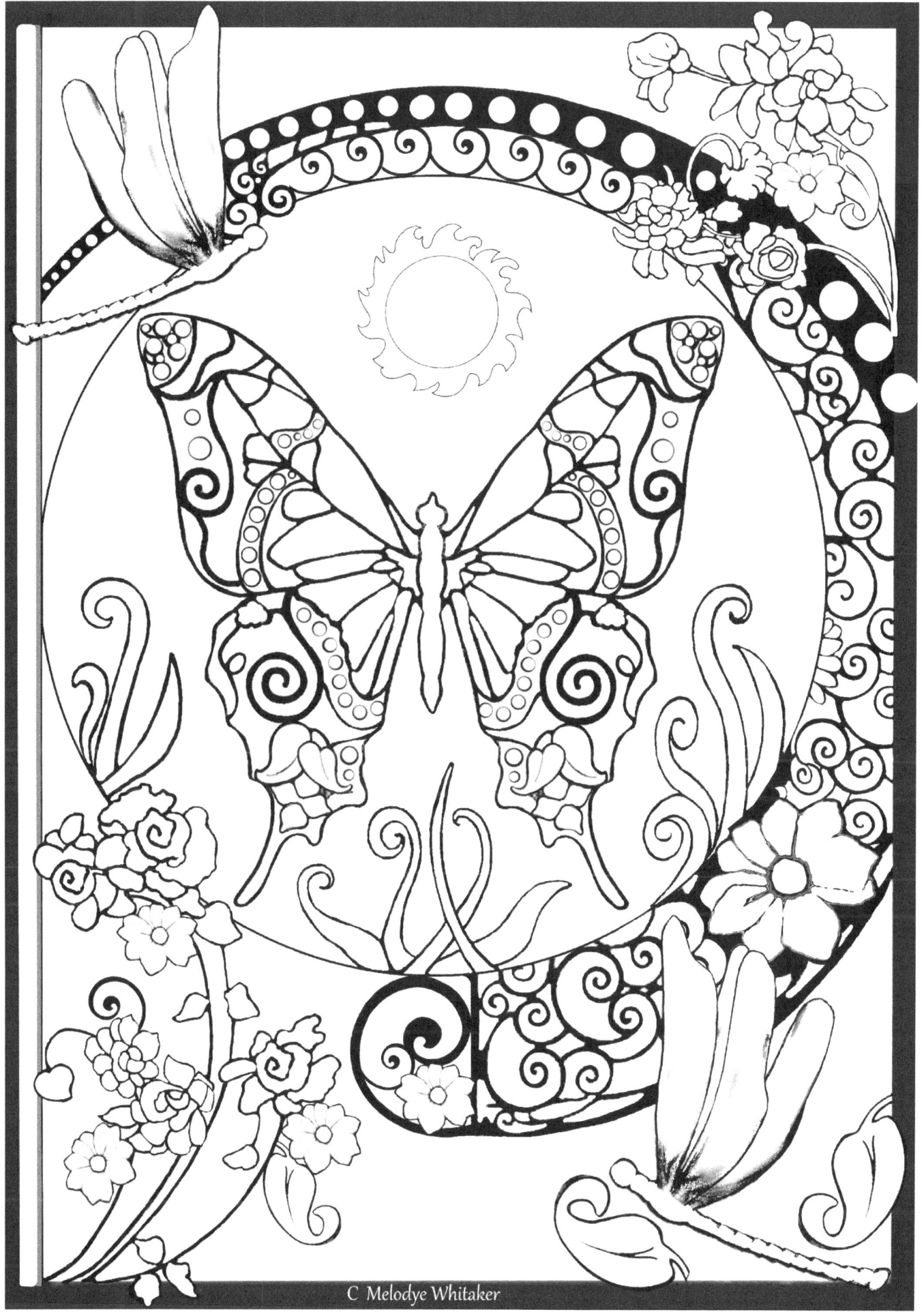

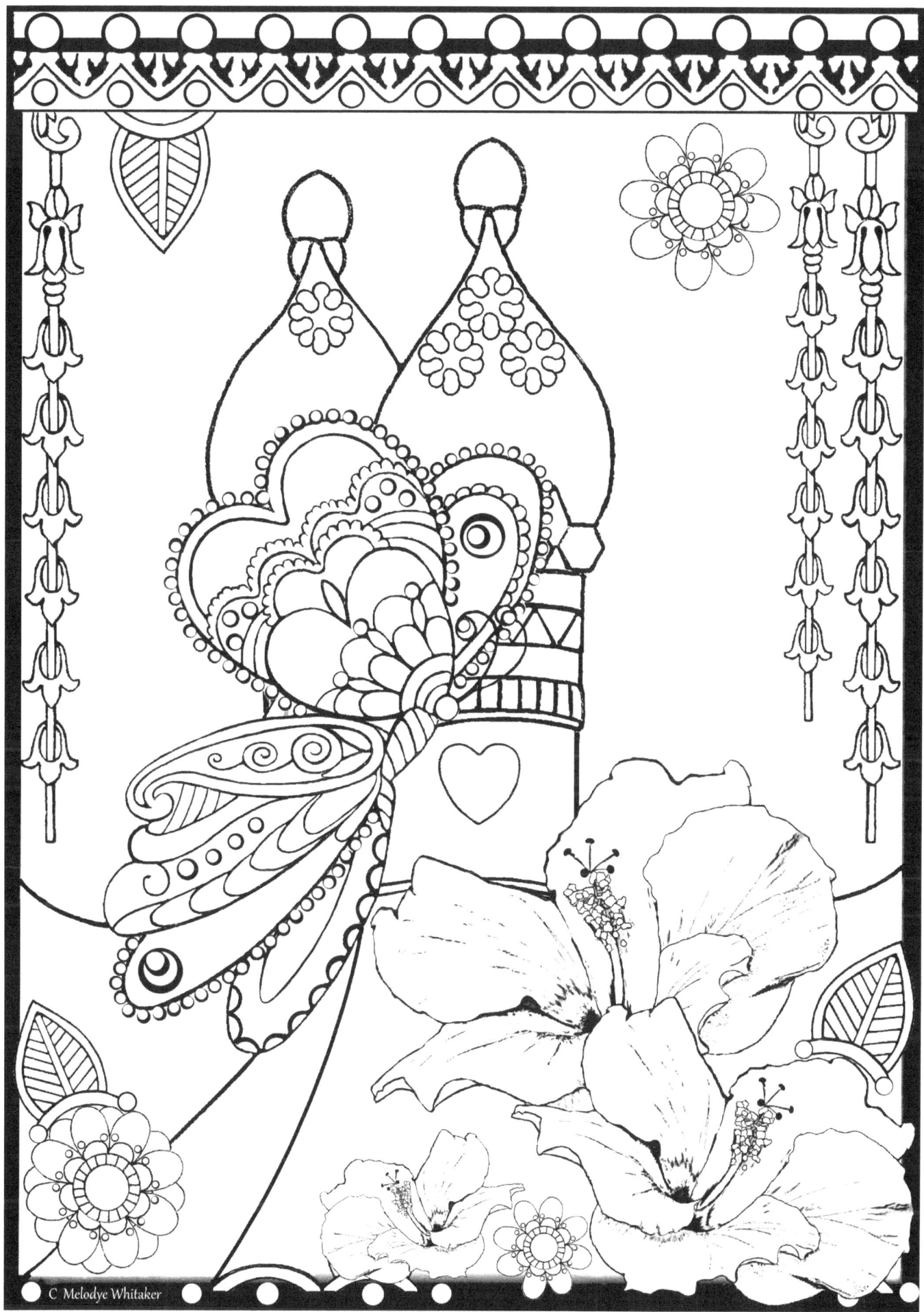

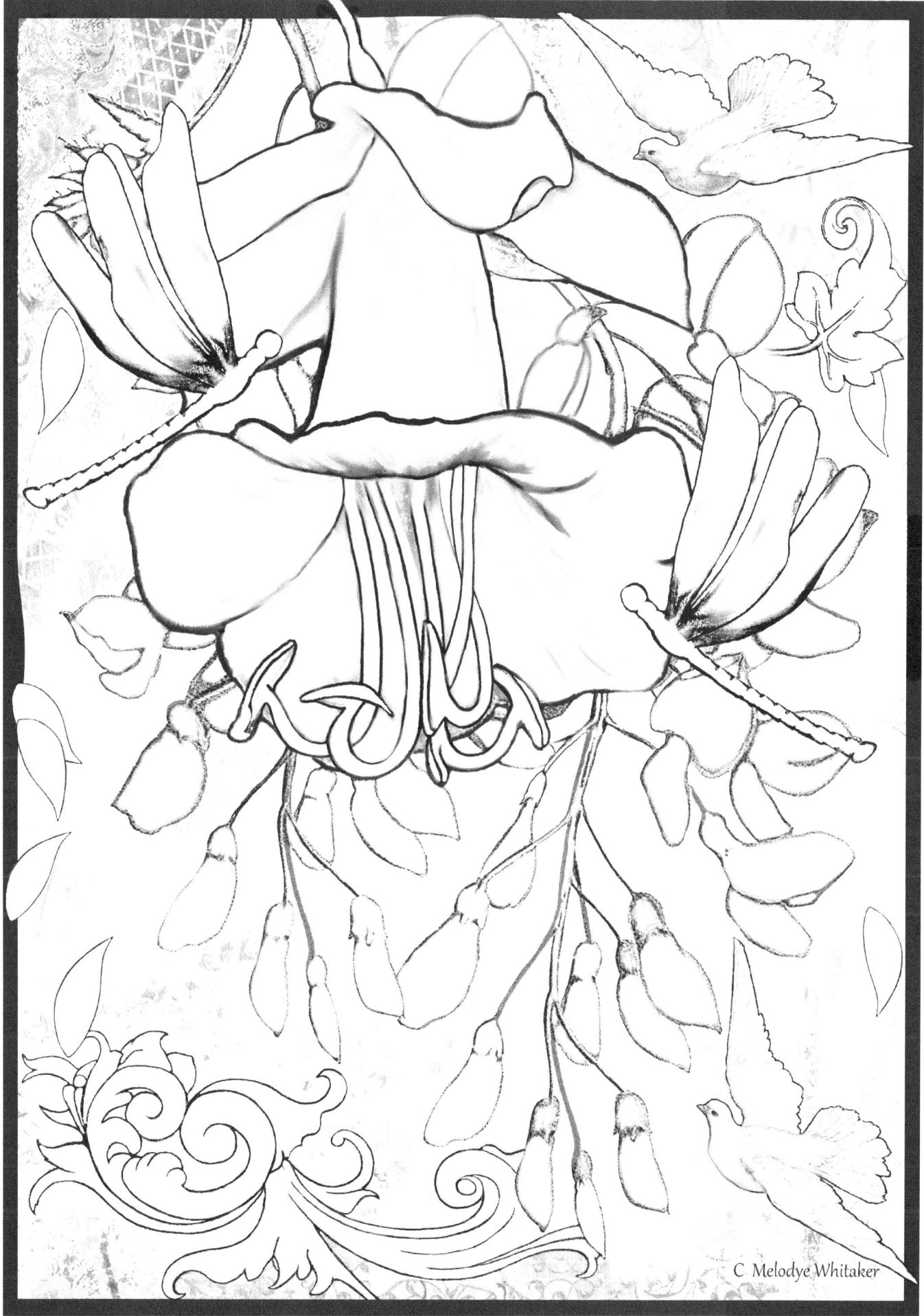

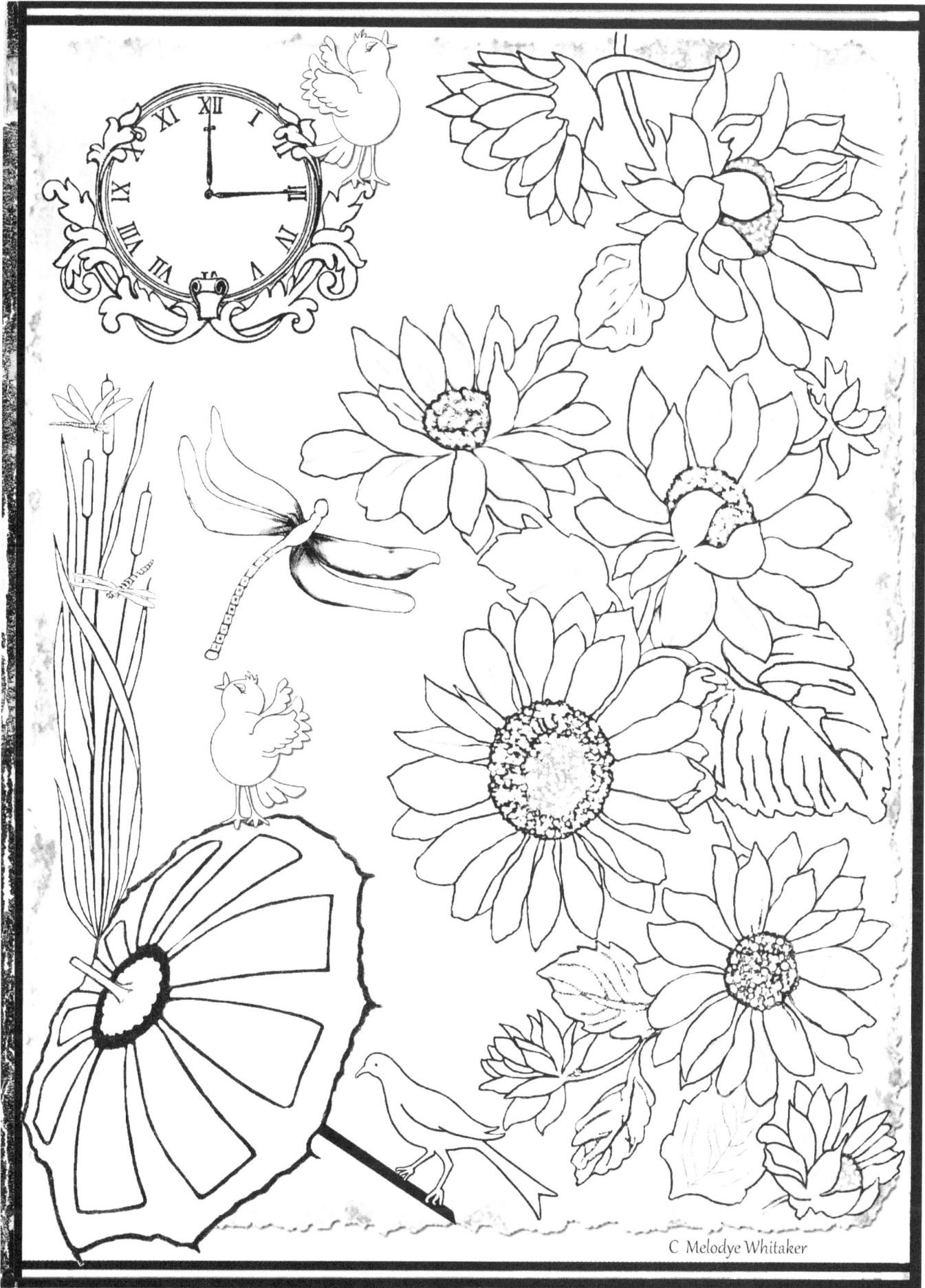

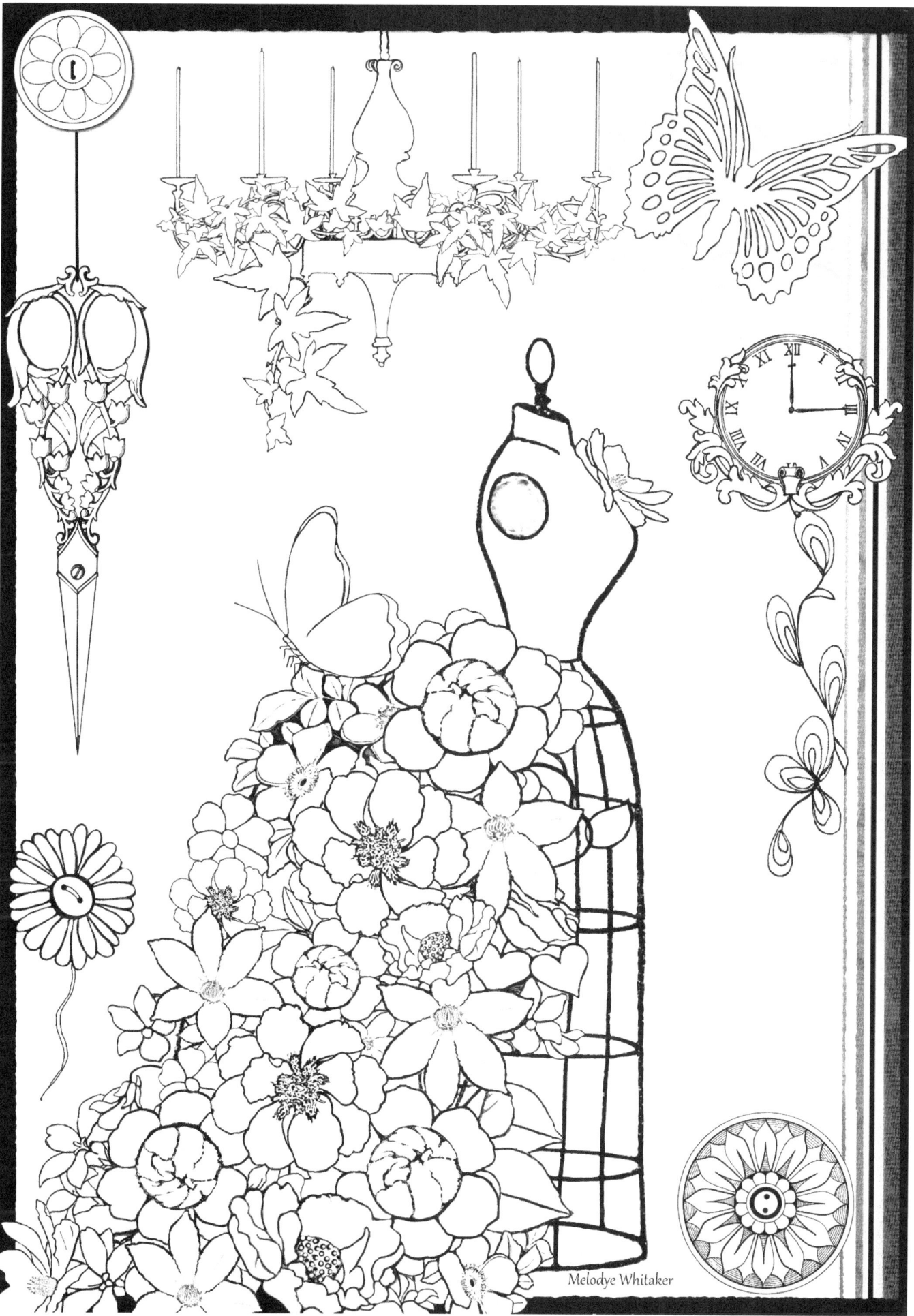
Melodye Whitaker

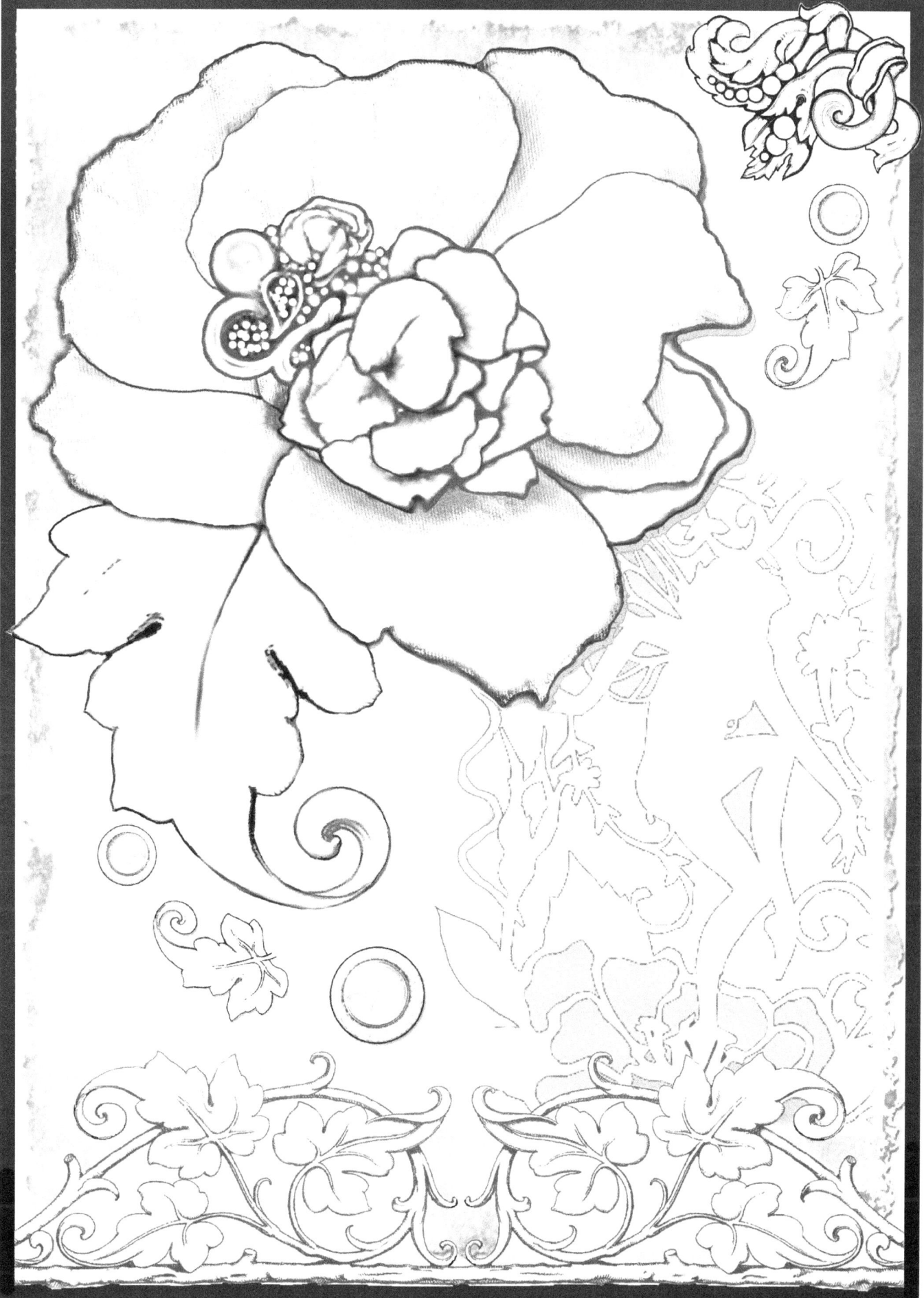

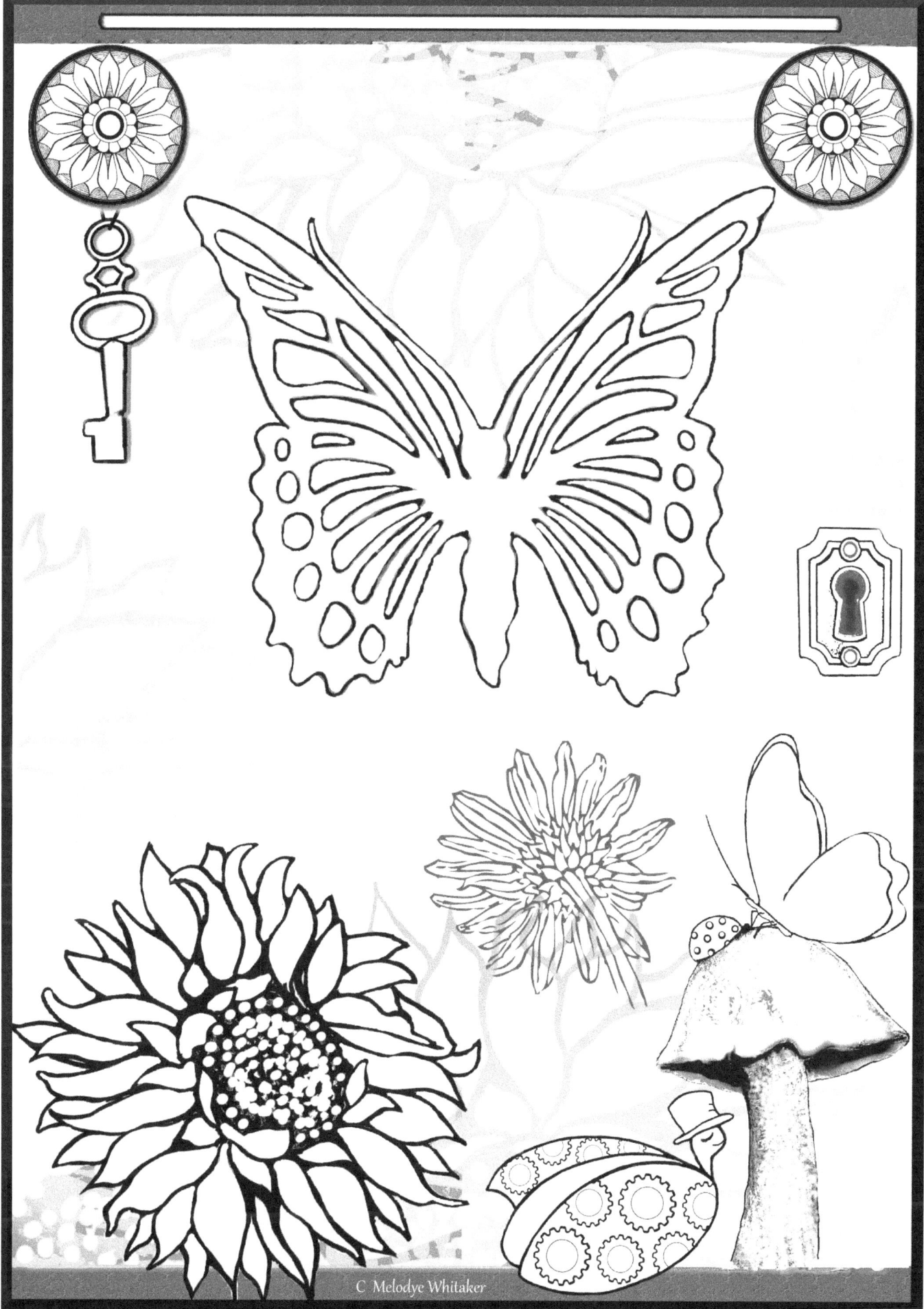

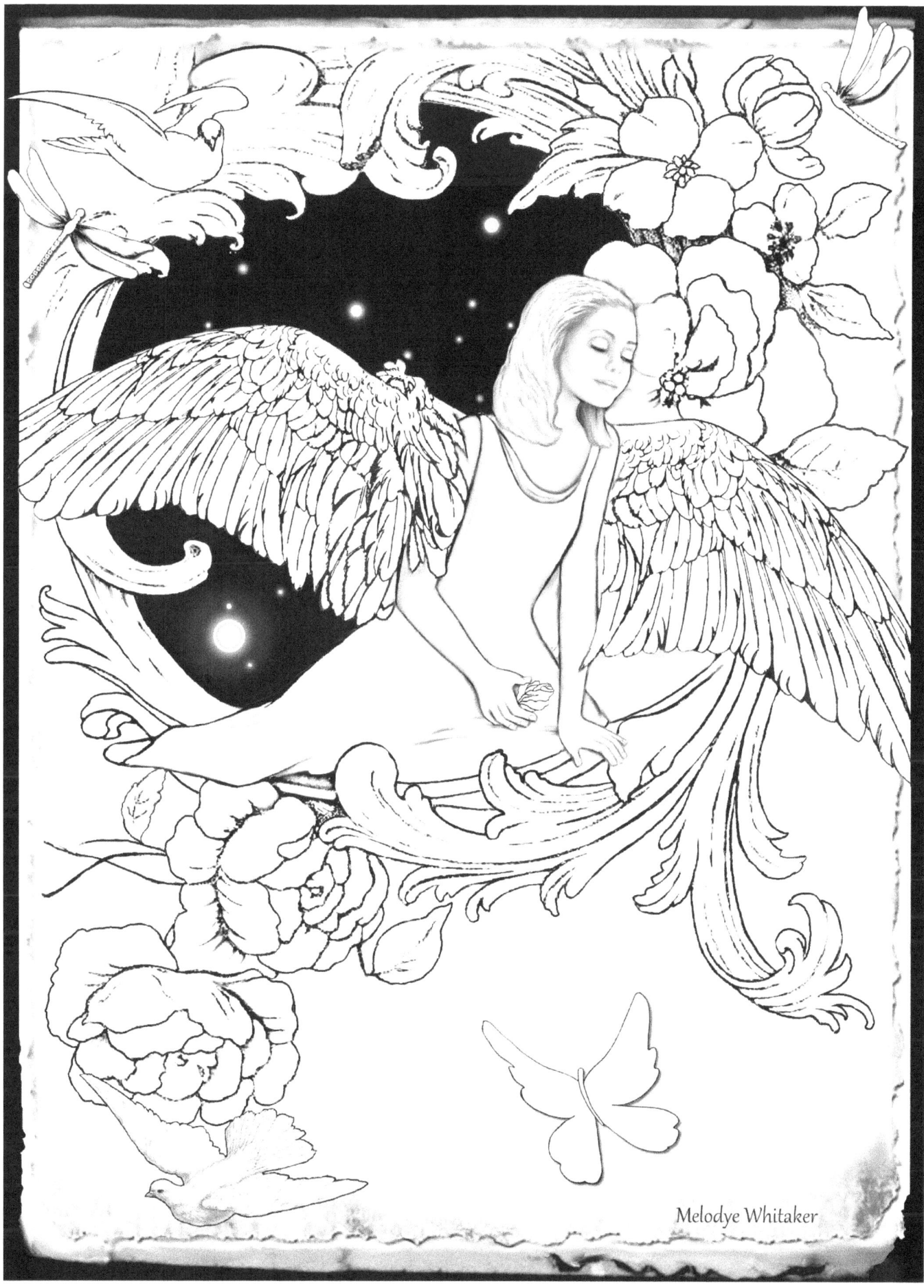

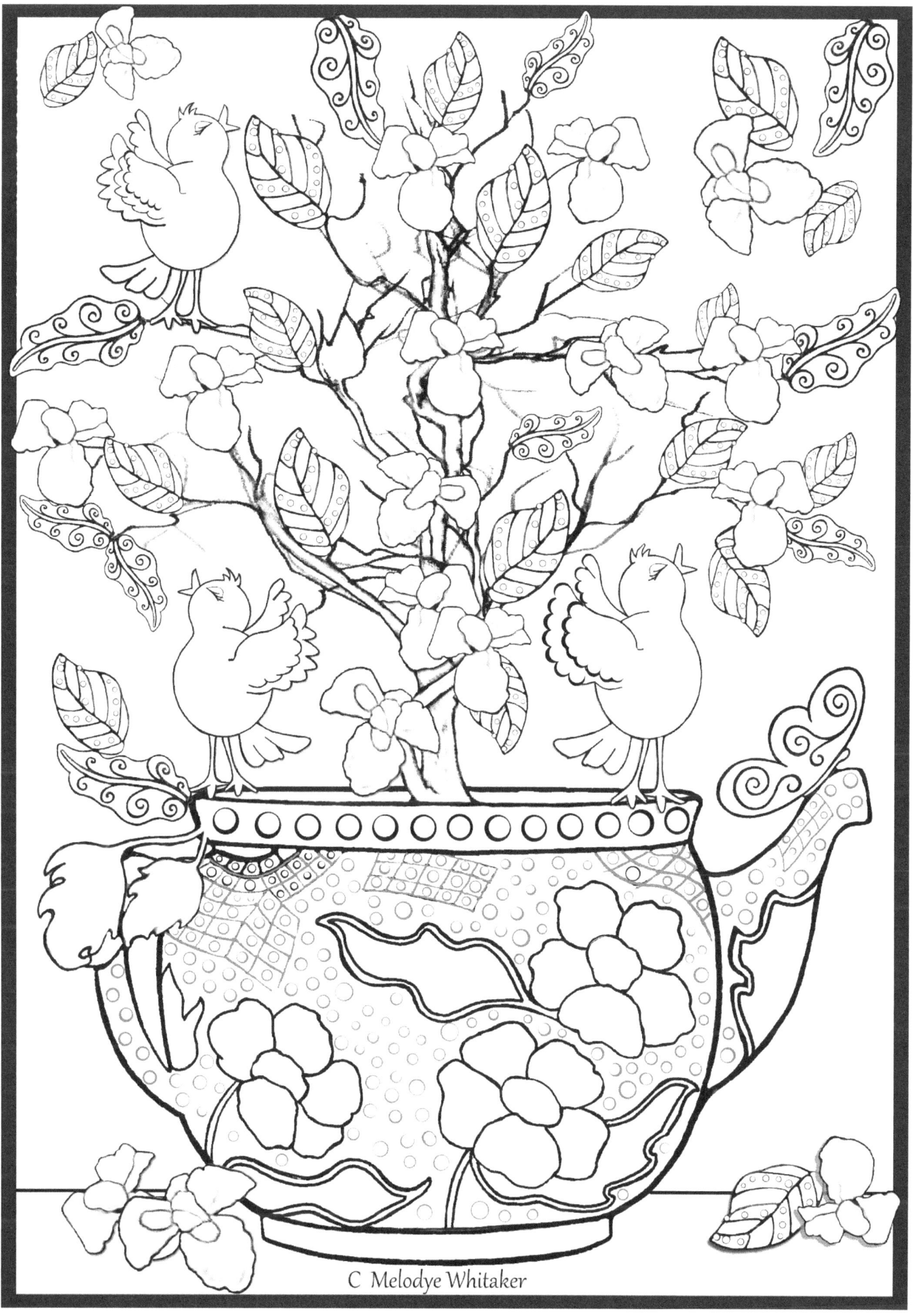

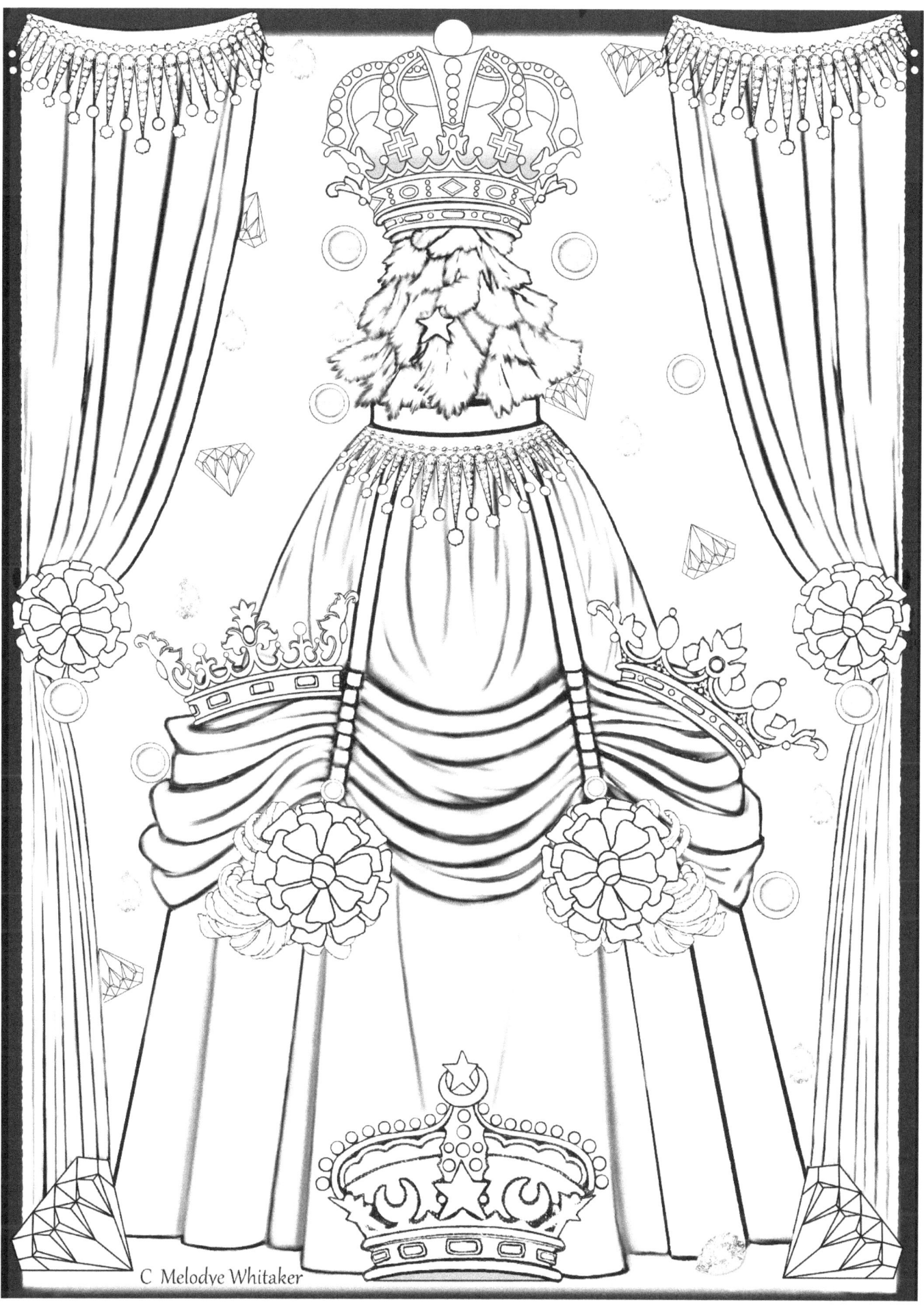

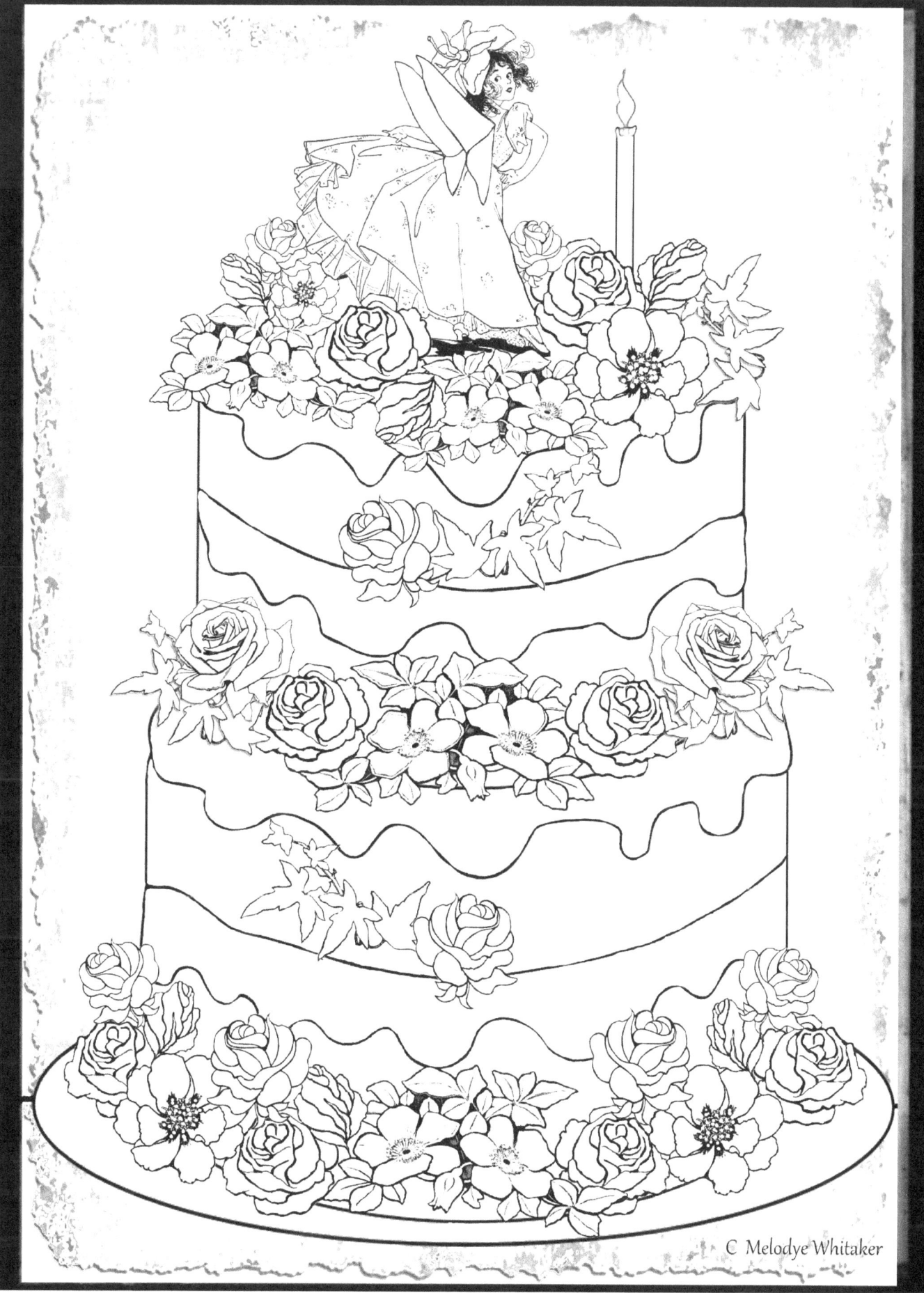
© Melodye Whitaker

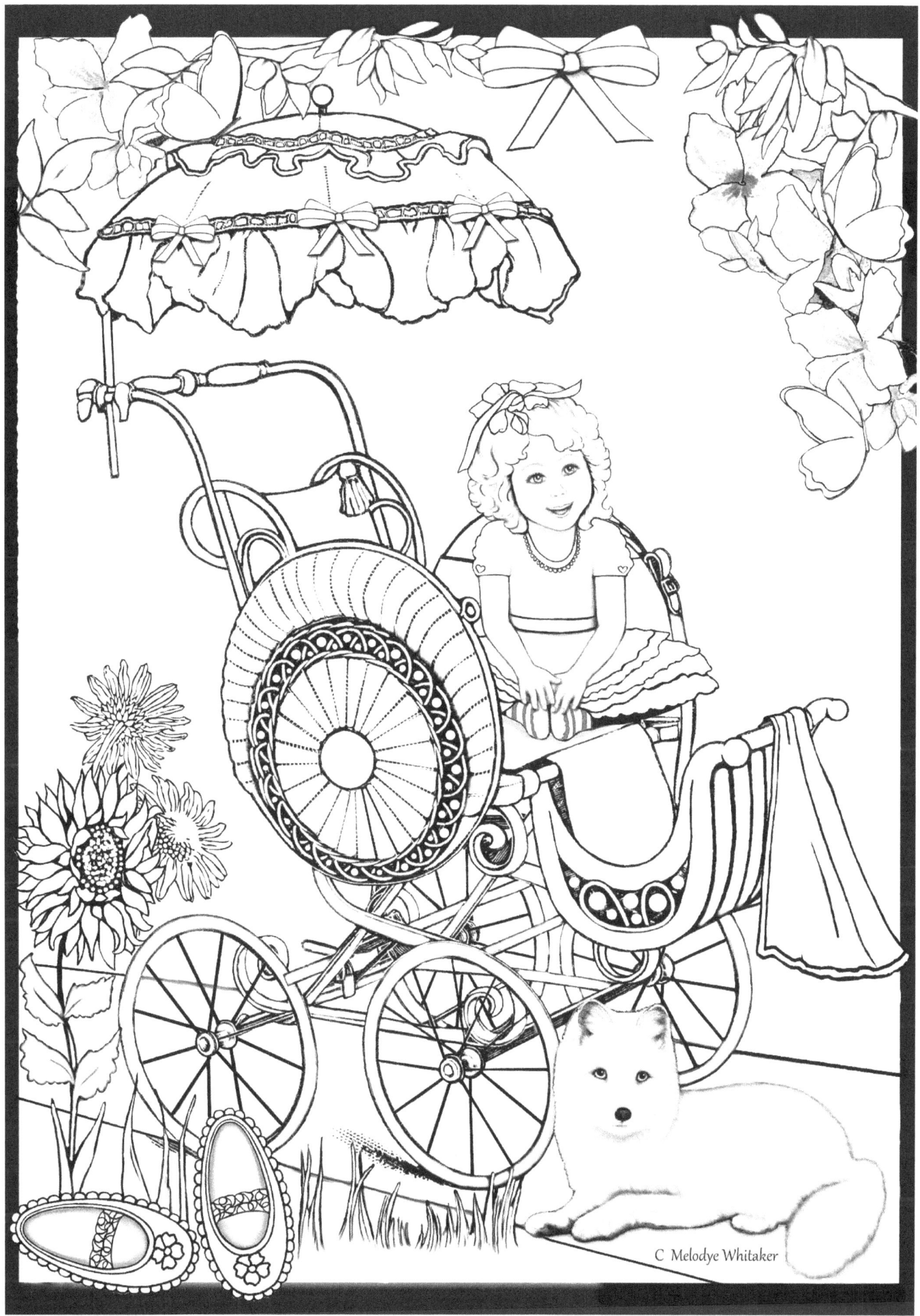

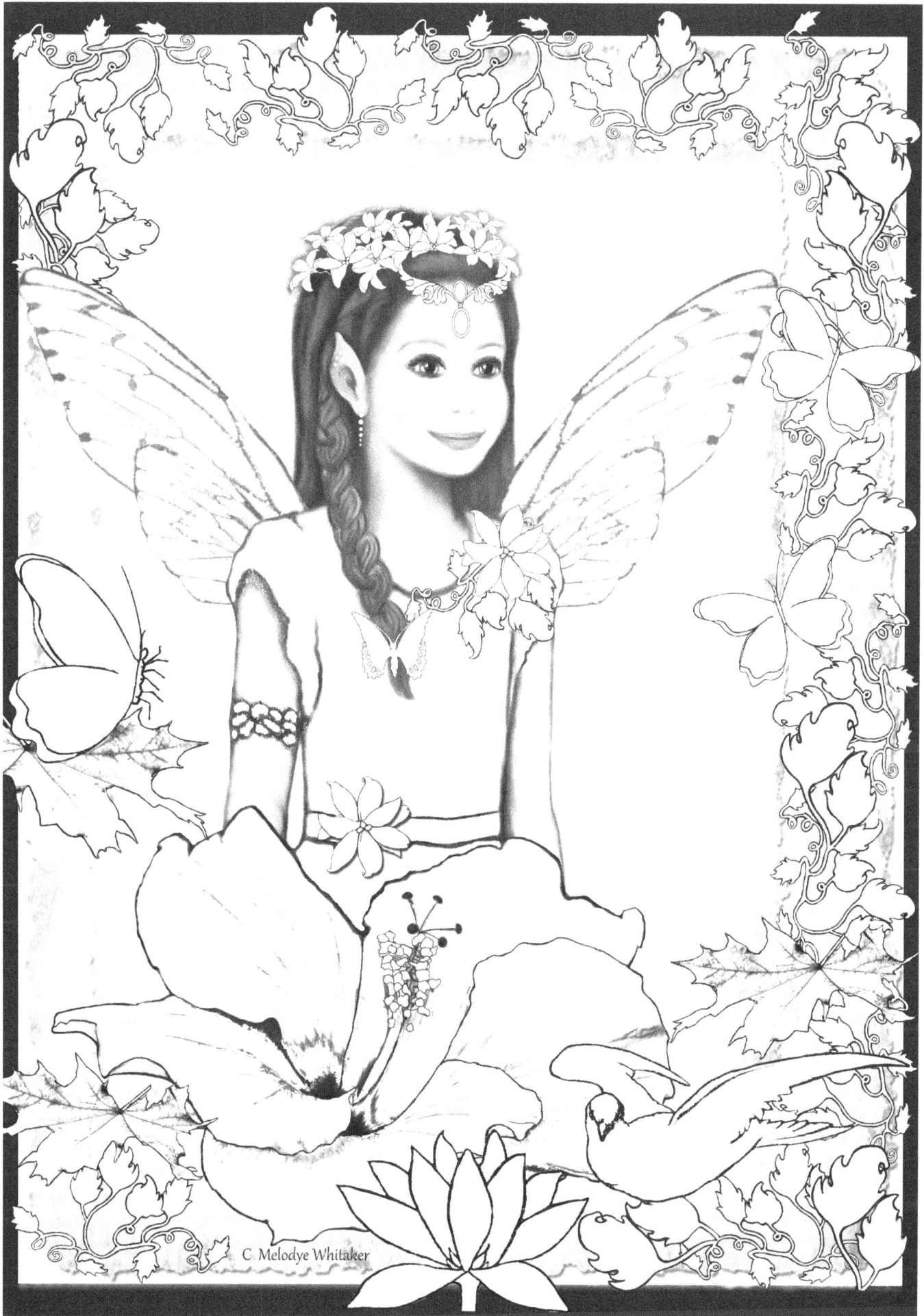

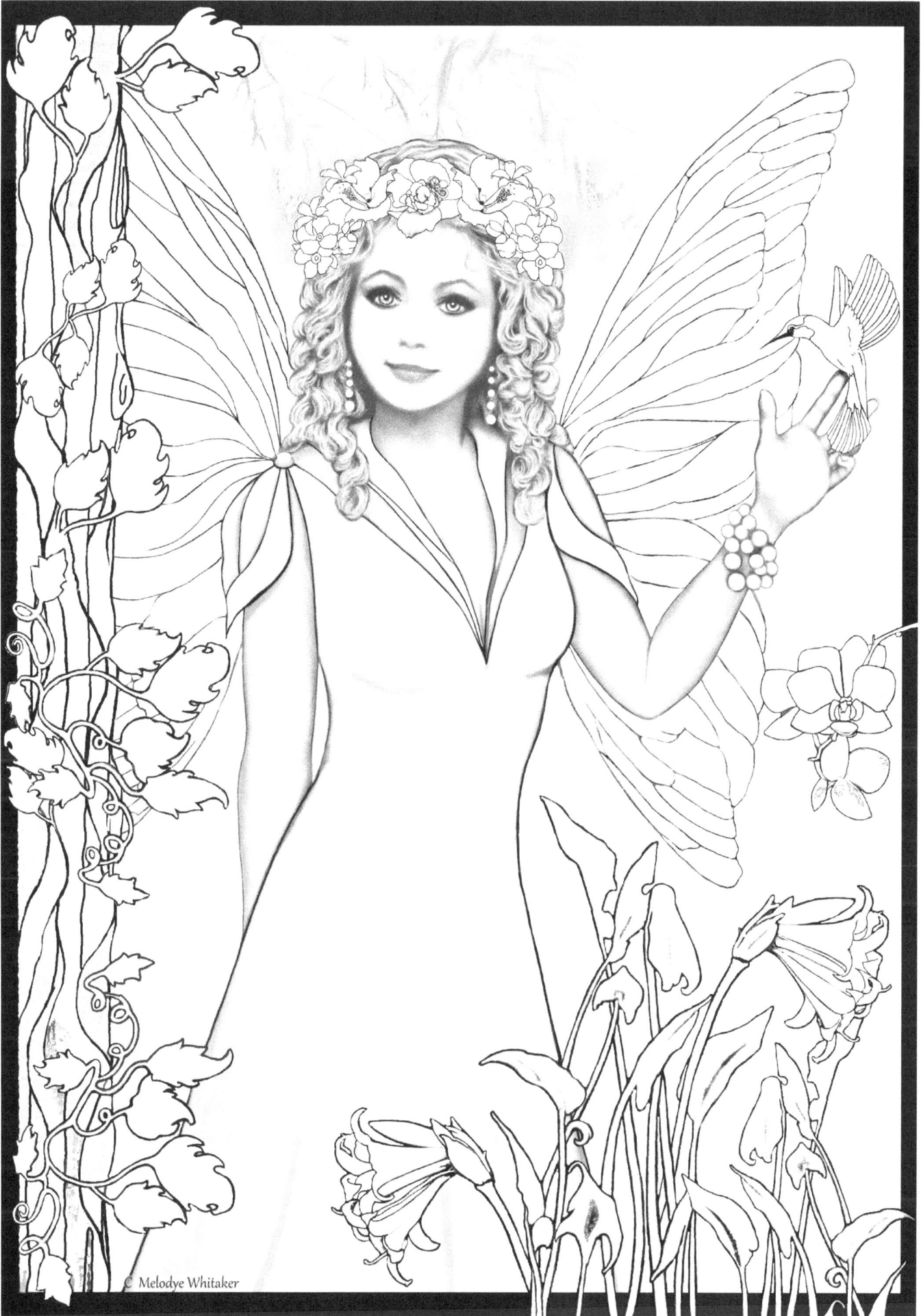

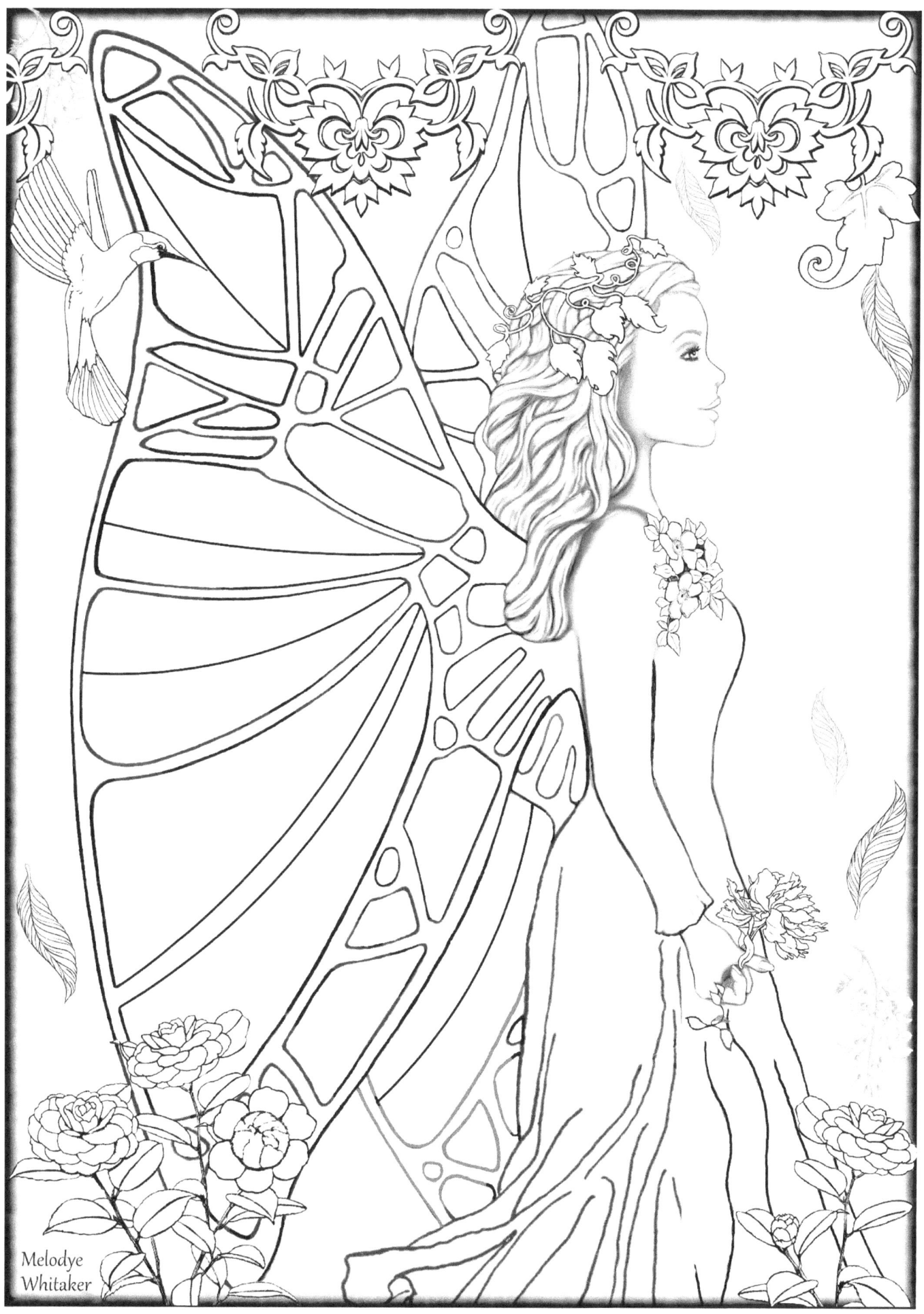

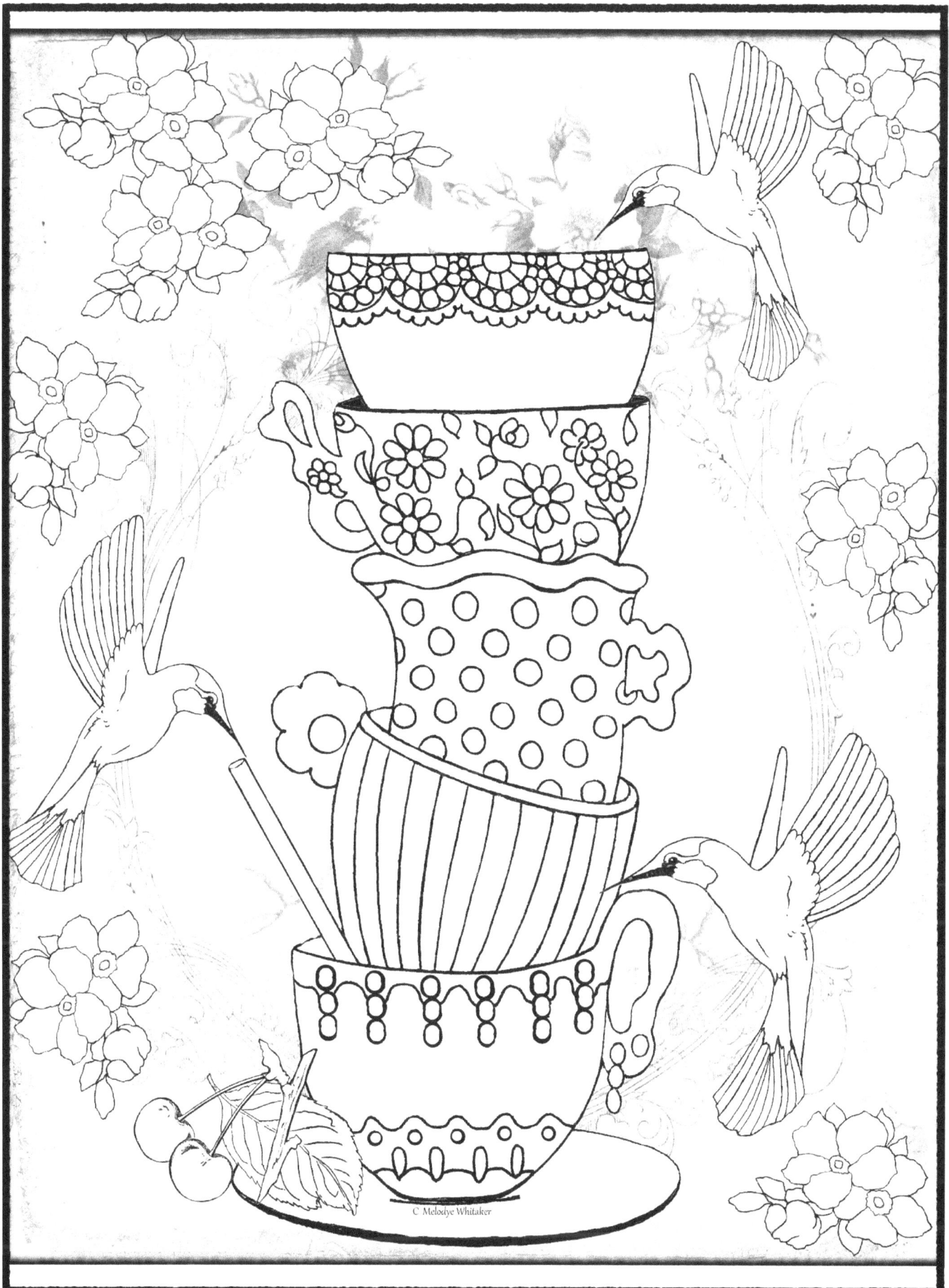

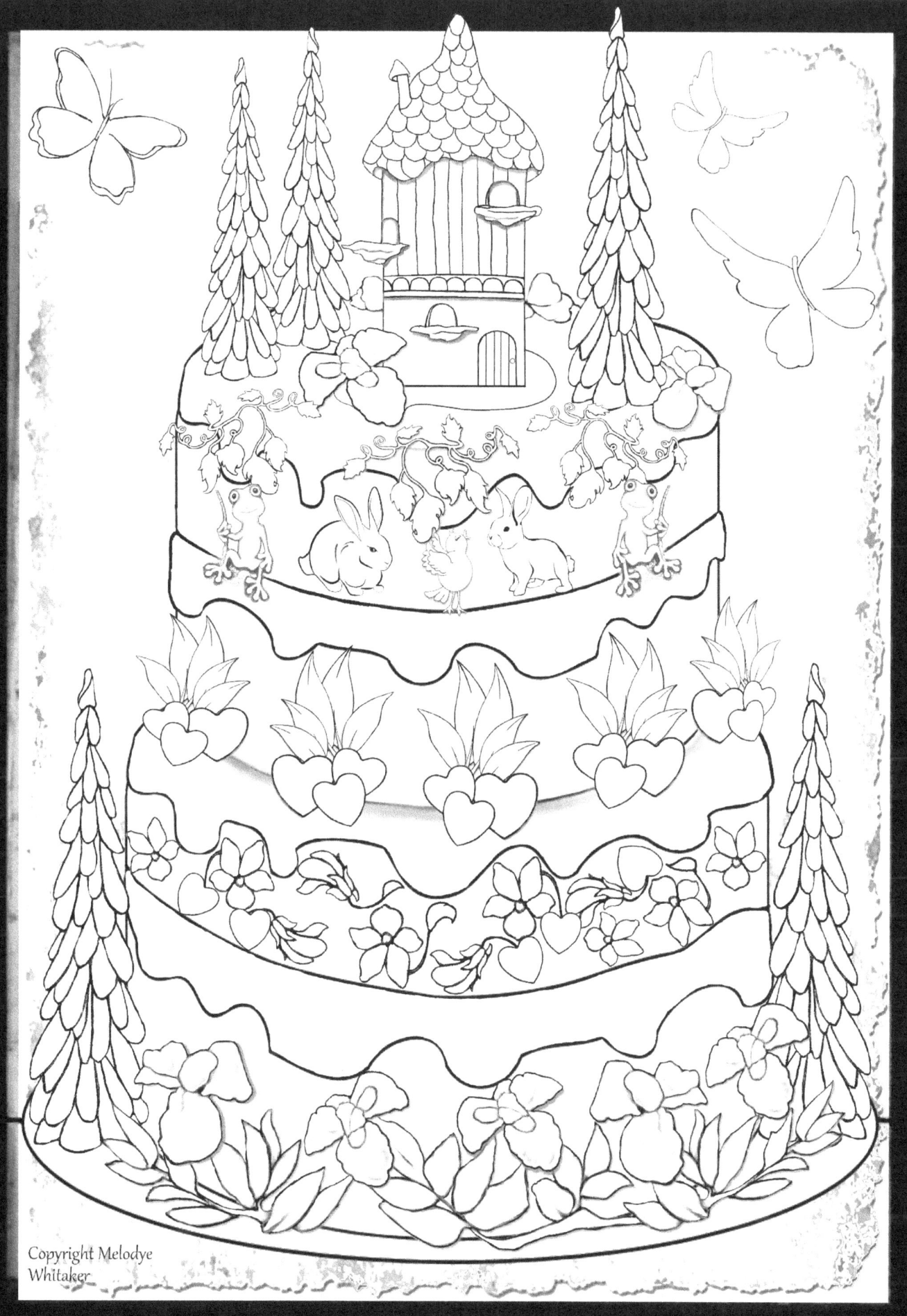

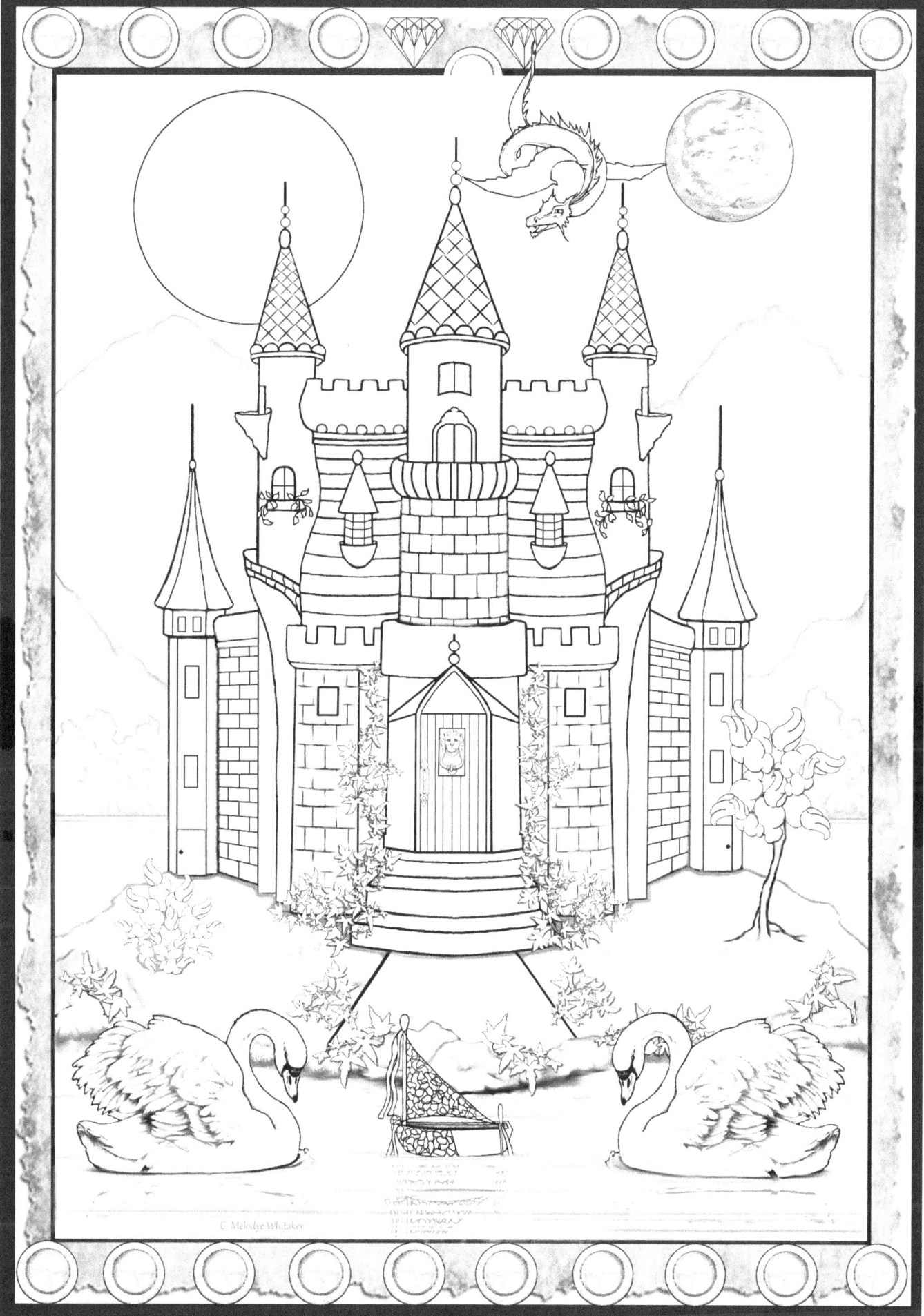

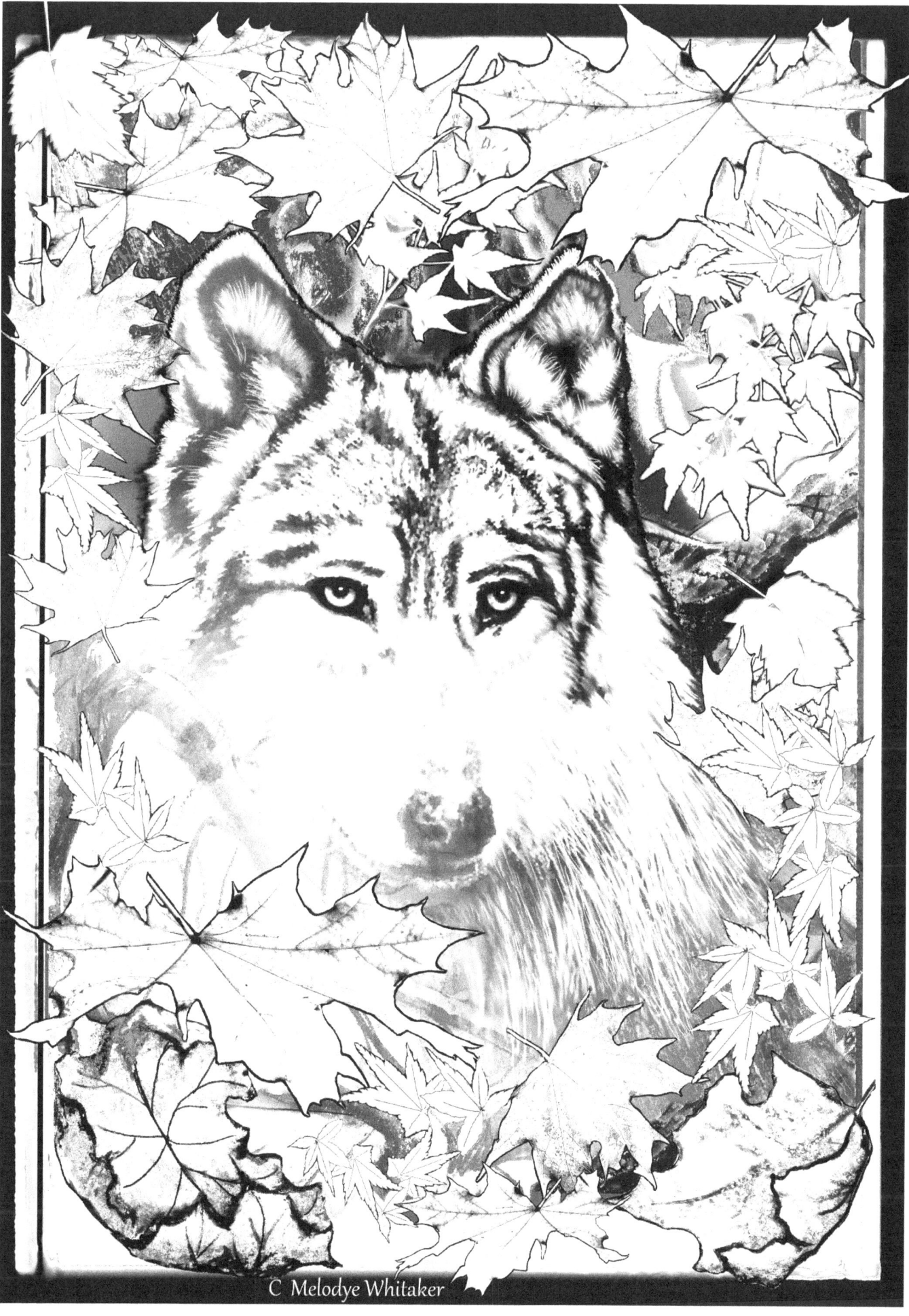

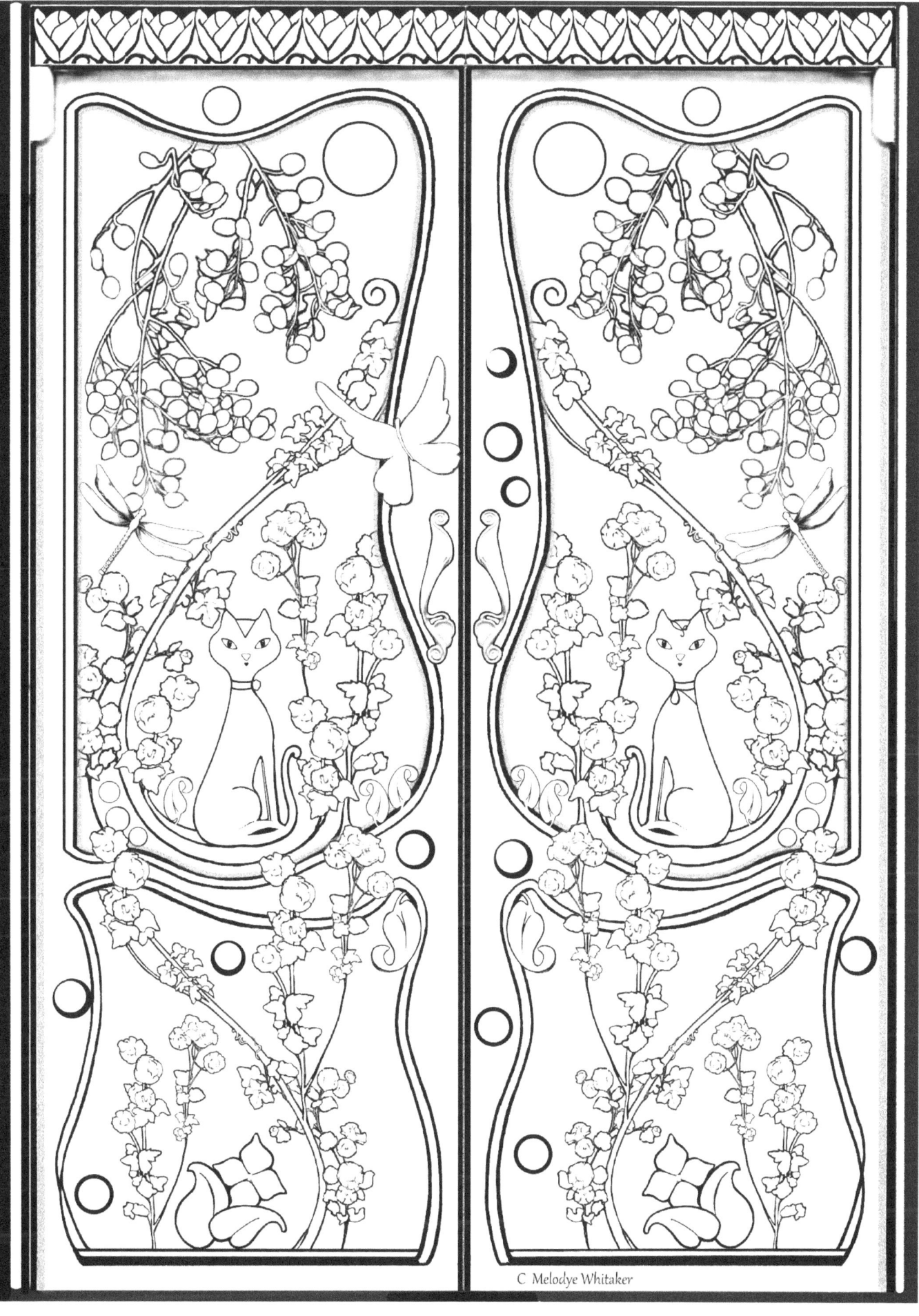

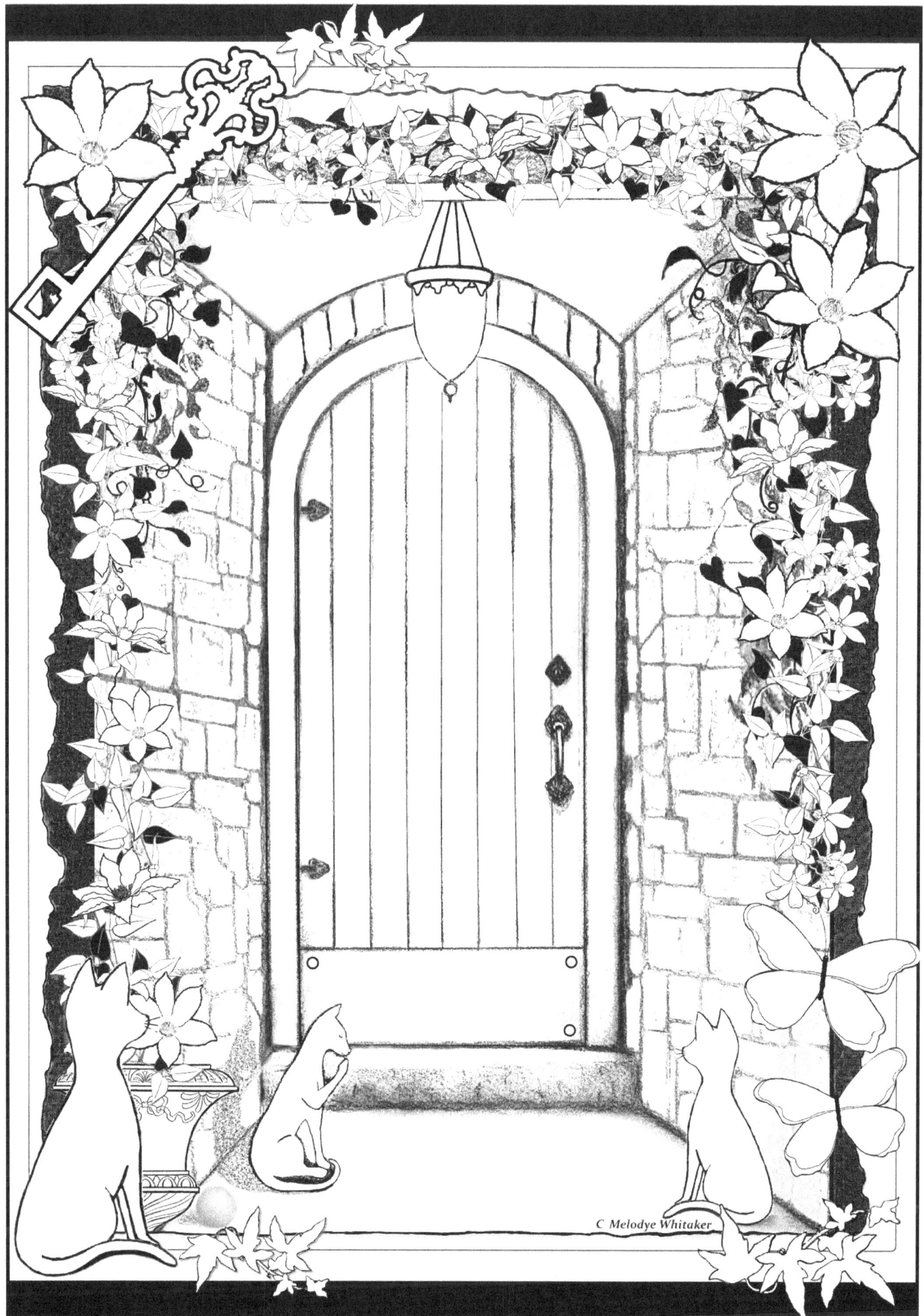

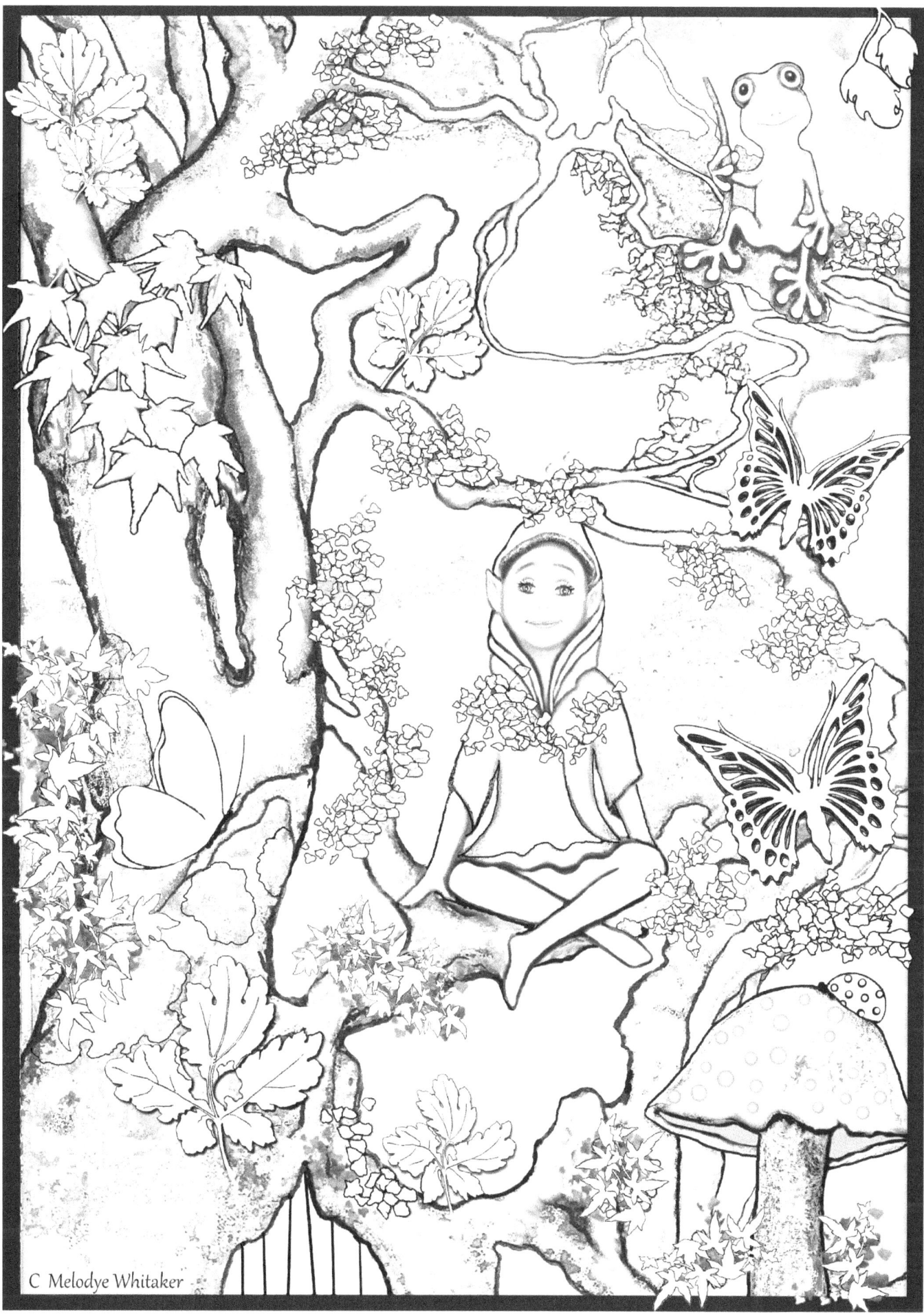

Decorate your Cake!

On the next page you will find a base image of a cake. You can use these designs to try your hand at collage. Be sure to colour the pieces before you cut them out. Colour your cake before you put on the decorations. Cut them out and adhere to the cake with a glue stick or thin, double stick tape.

If you prefer, try cutting out other pictures from magazines or books or pieces of colored paper and use that to decorate. Here is an example, but reach for the stars and be creative!

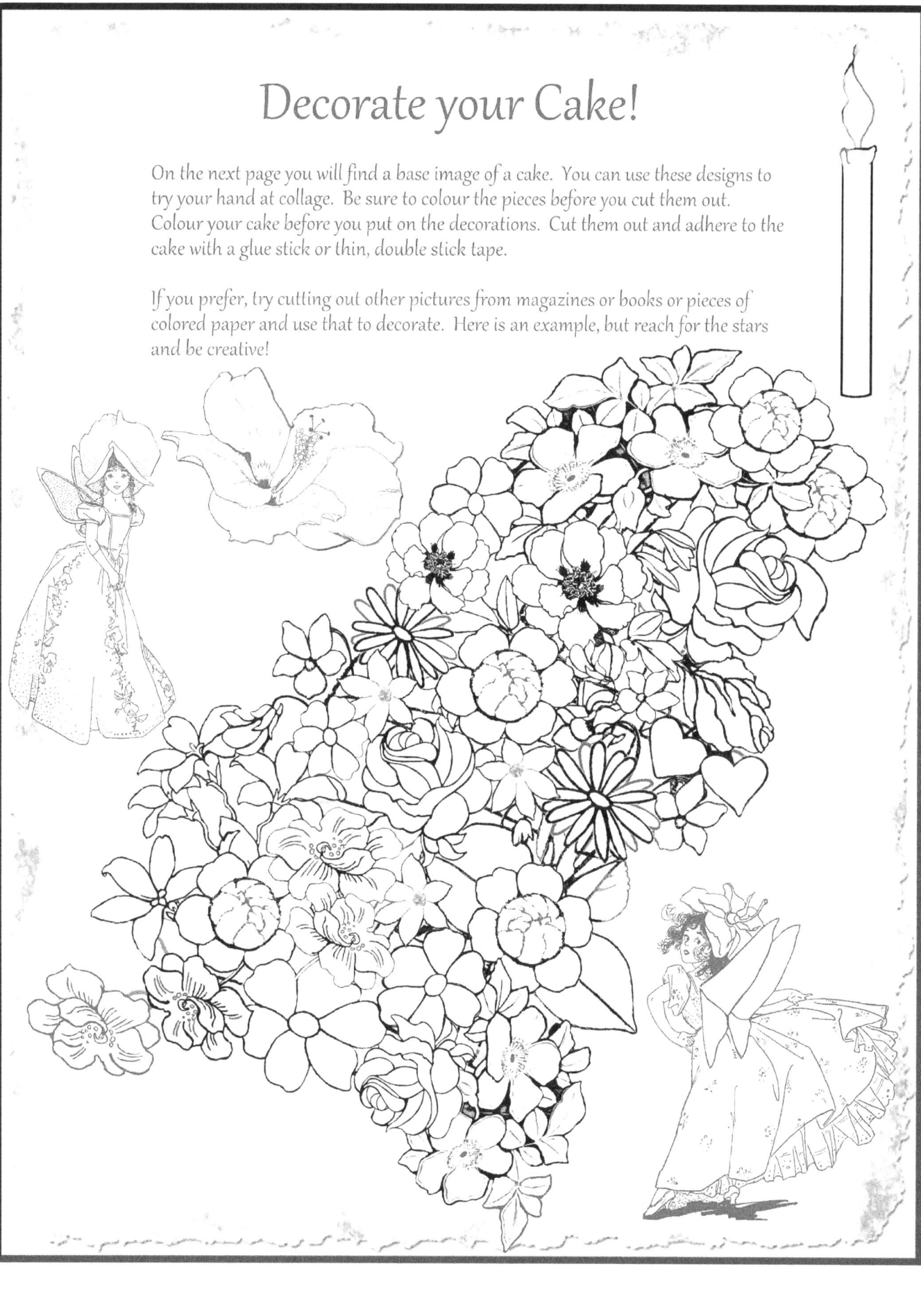

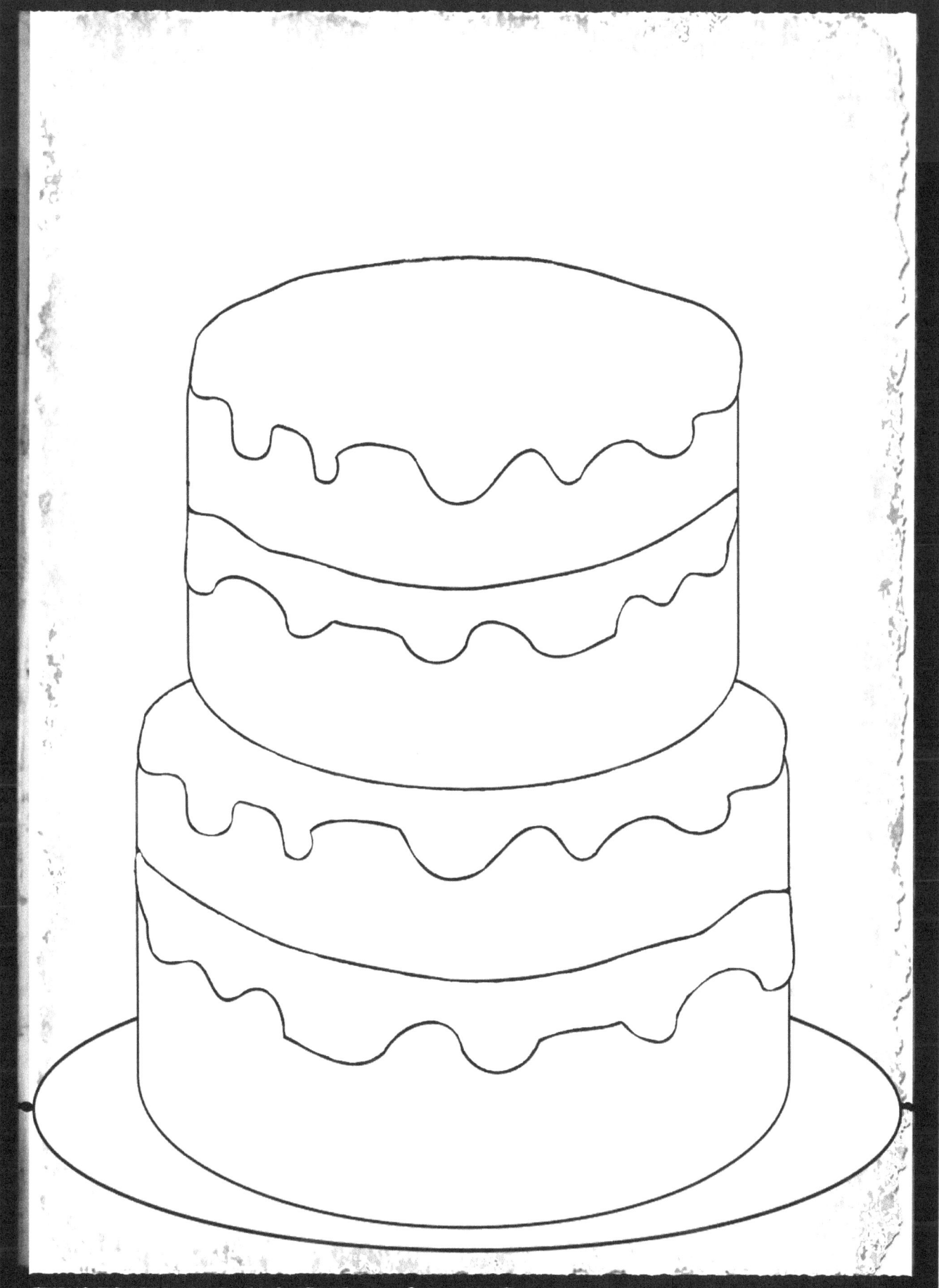

For Example.....

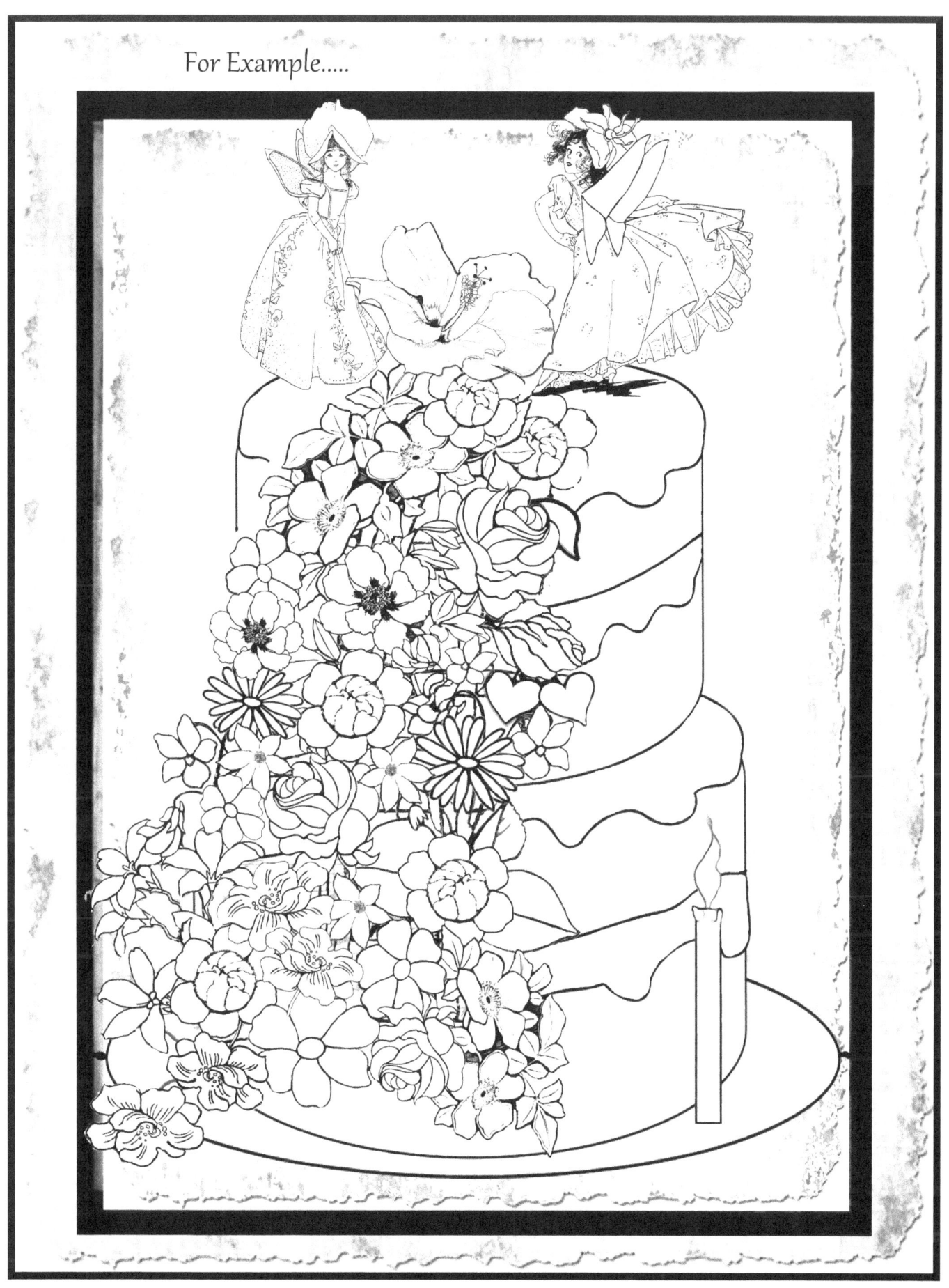

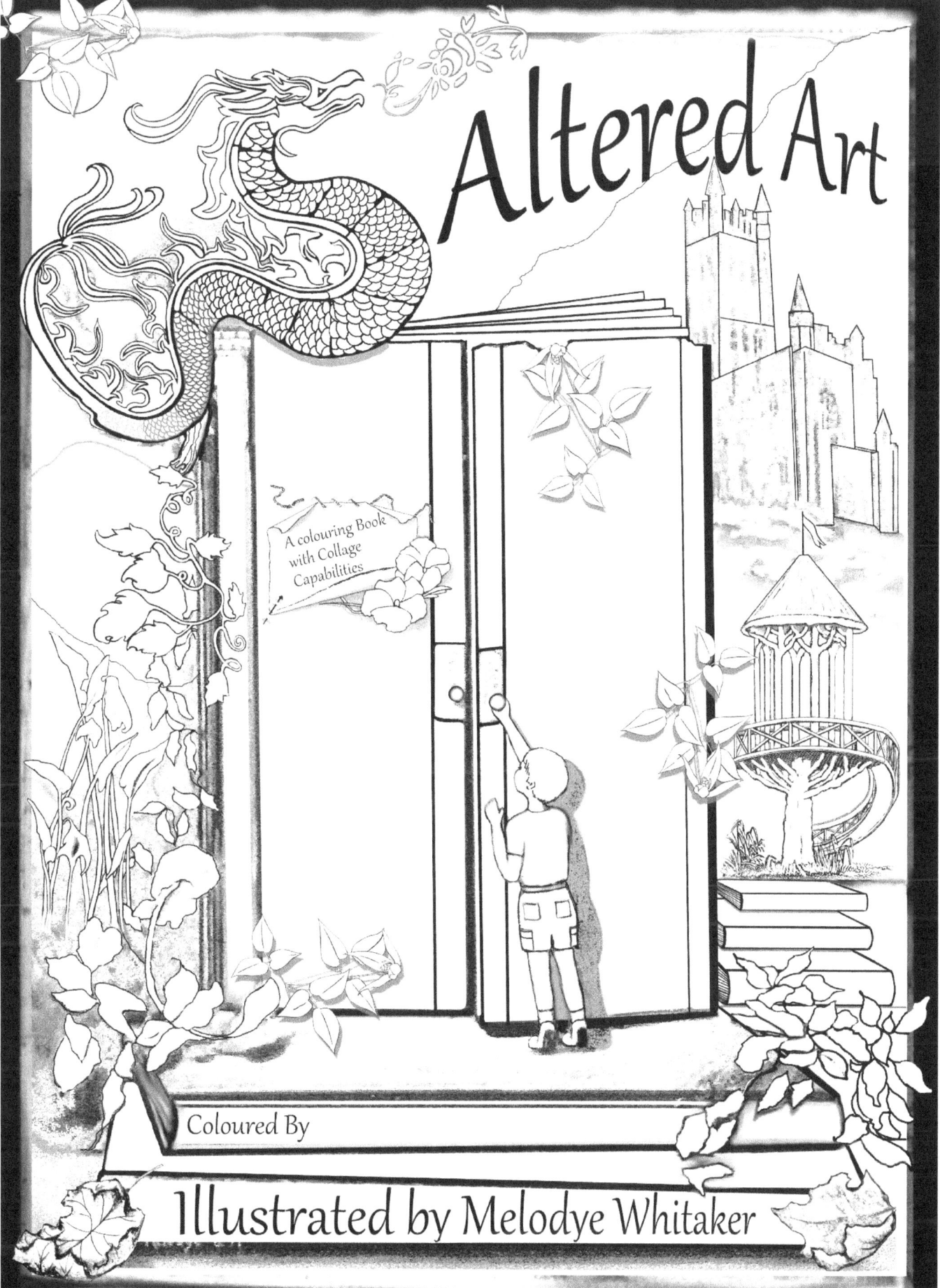

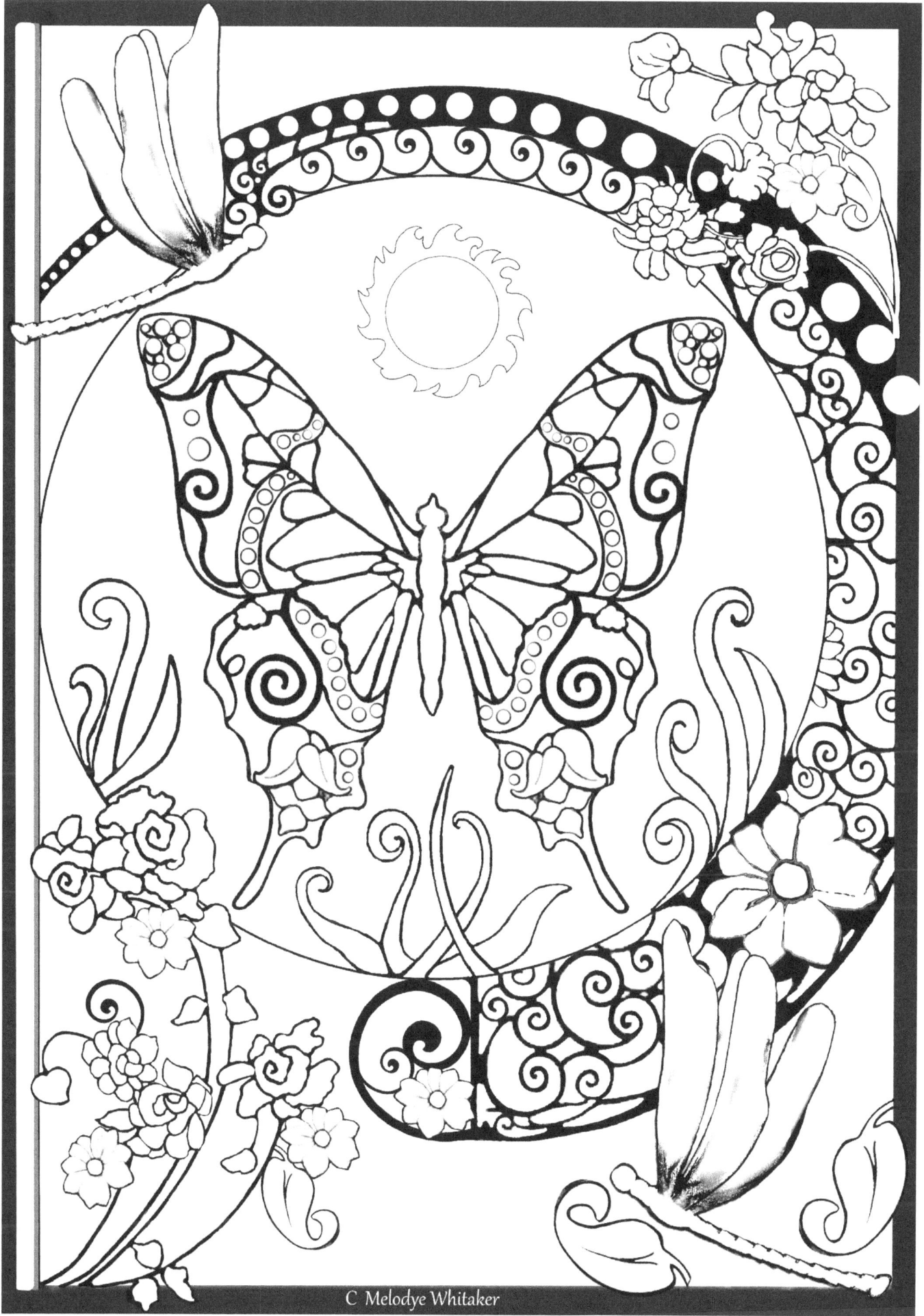
© Melodye Whitaker

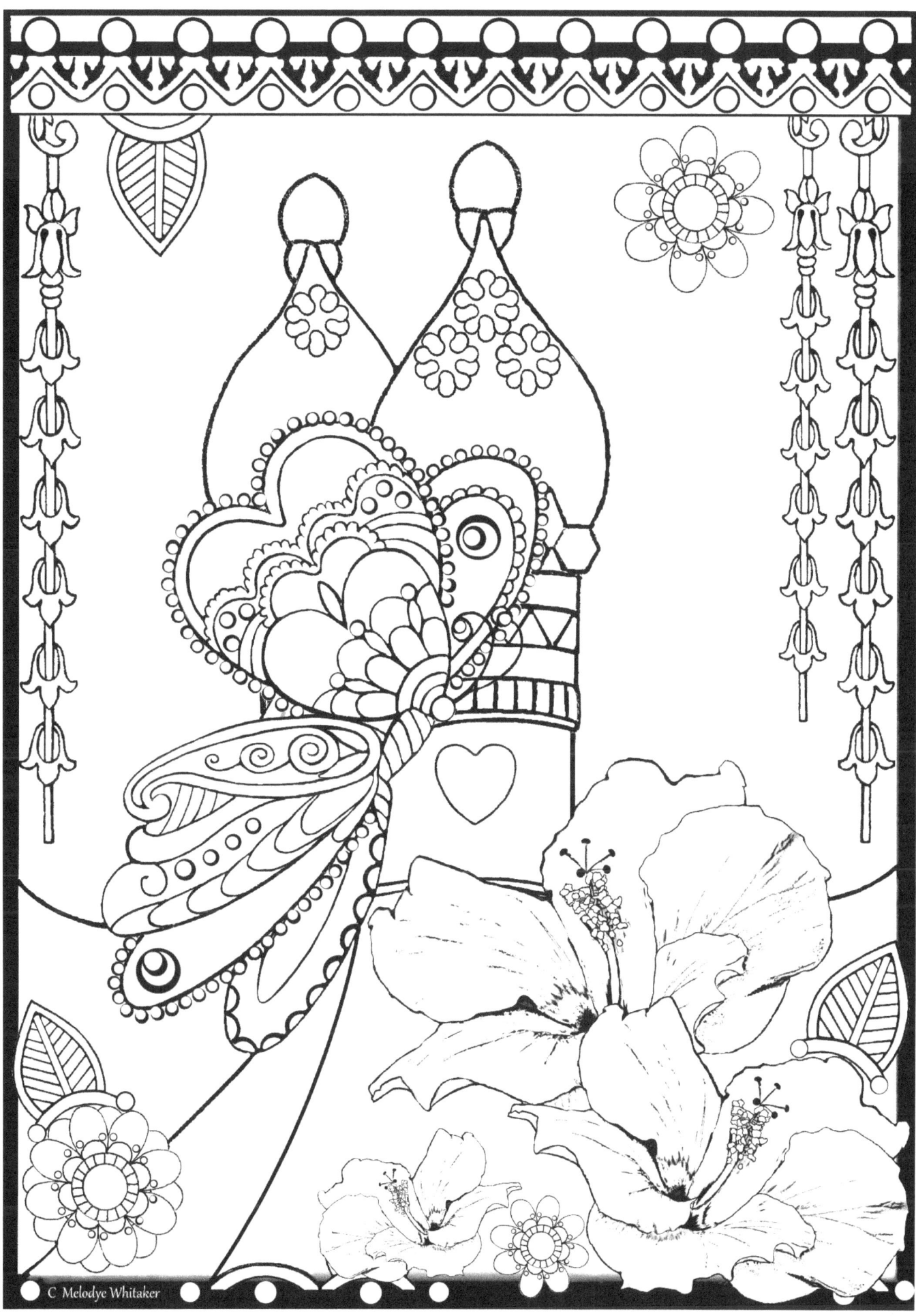

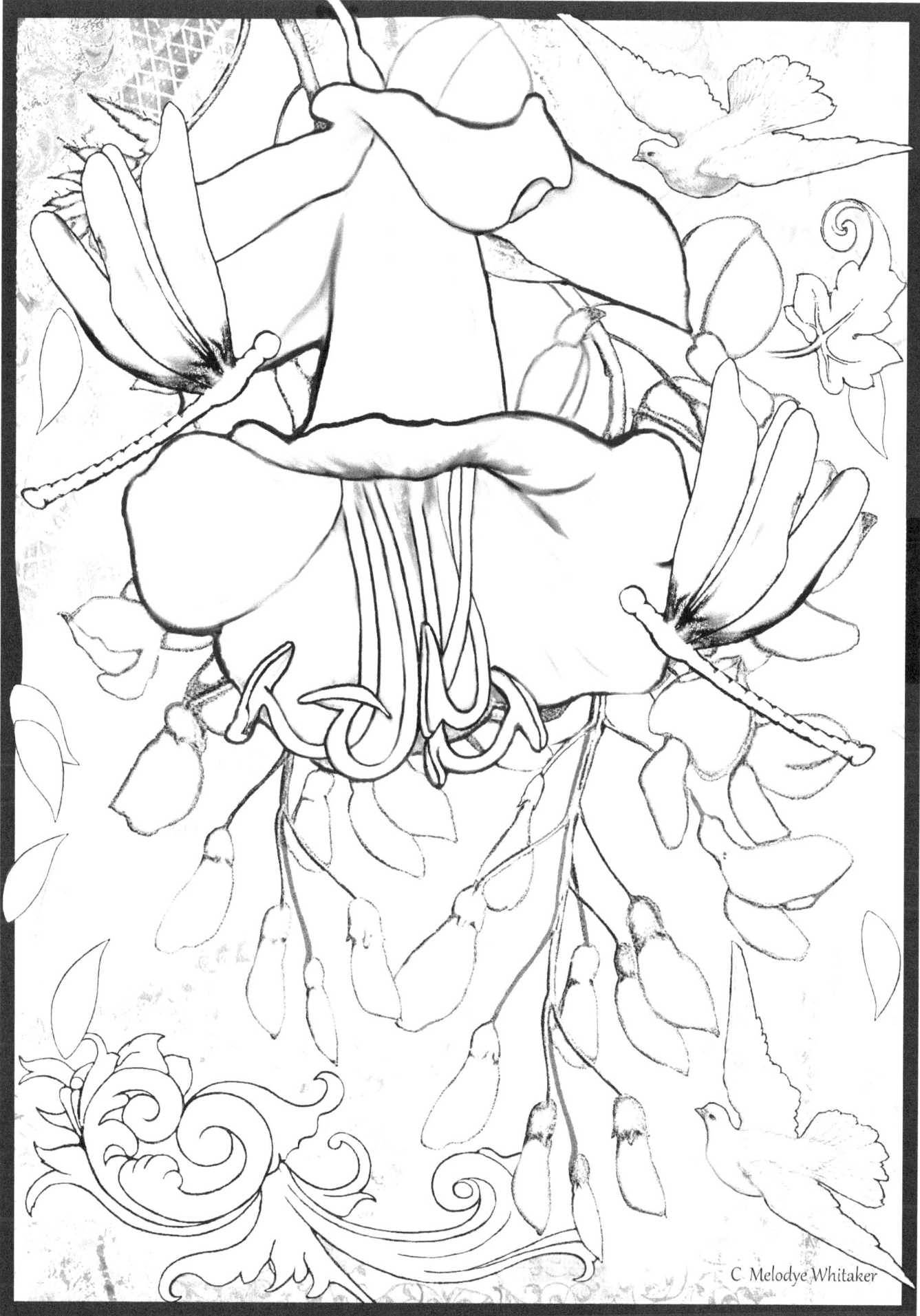

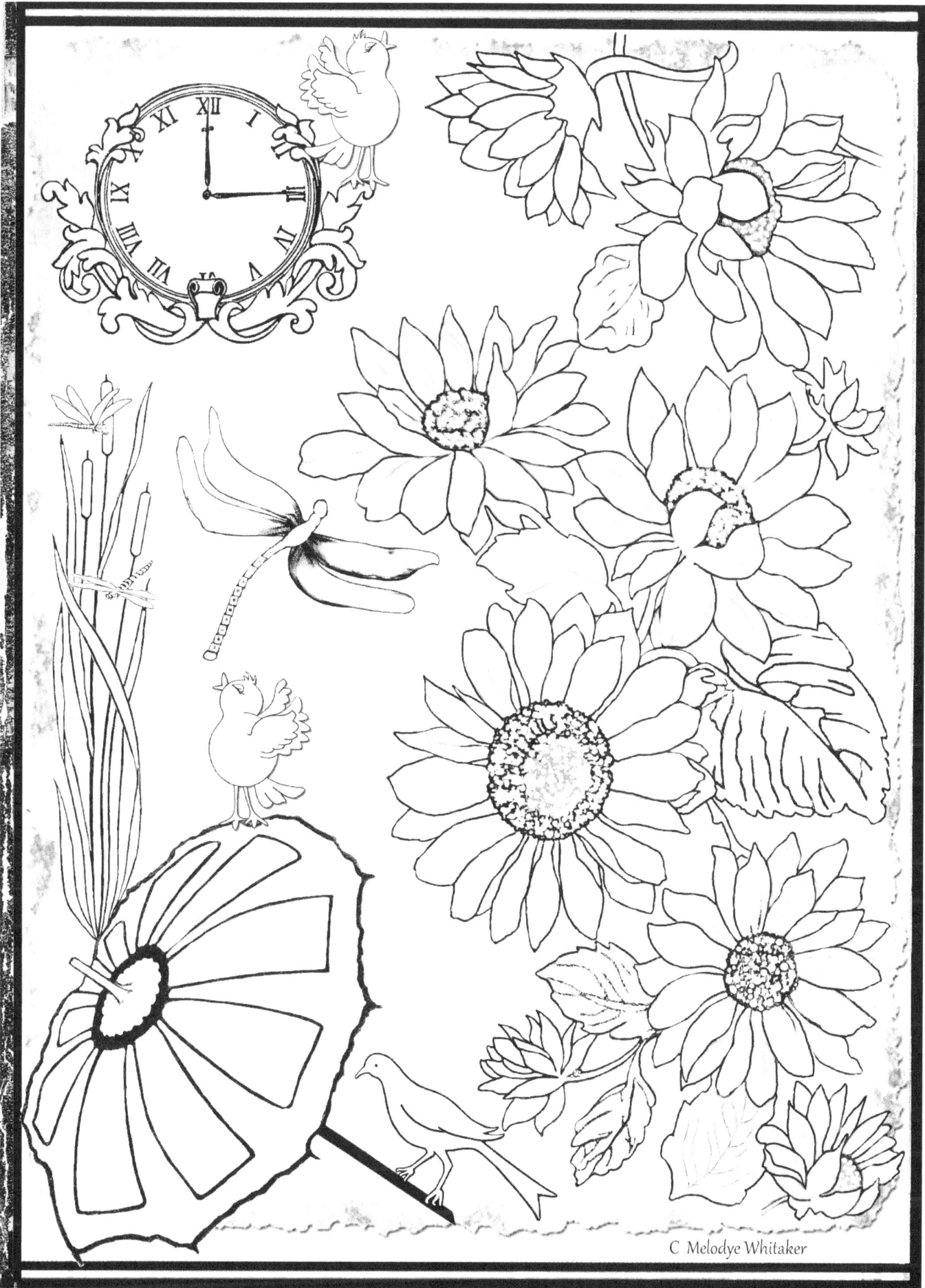
© Melodye Whitaker

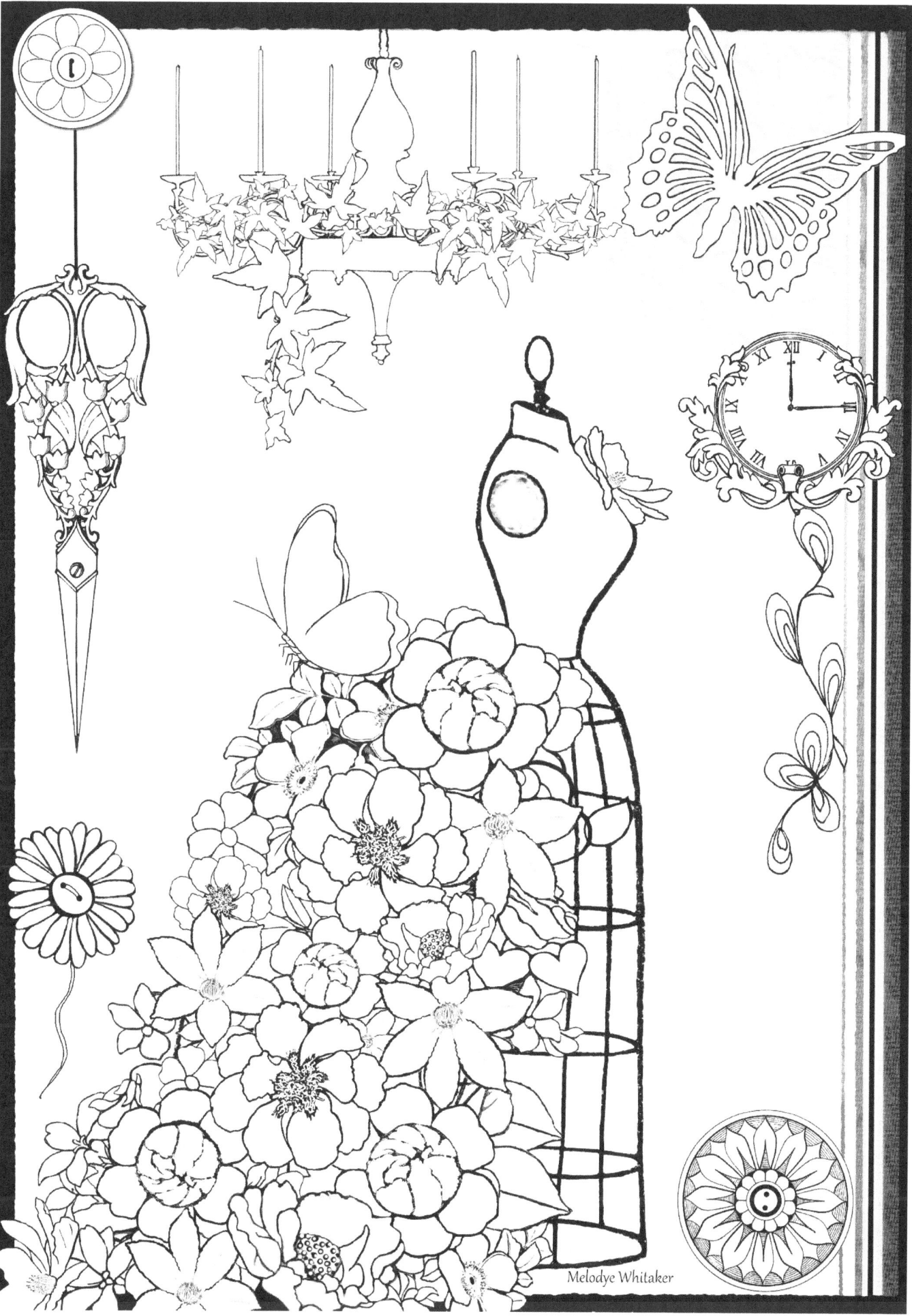

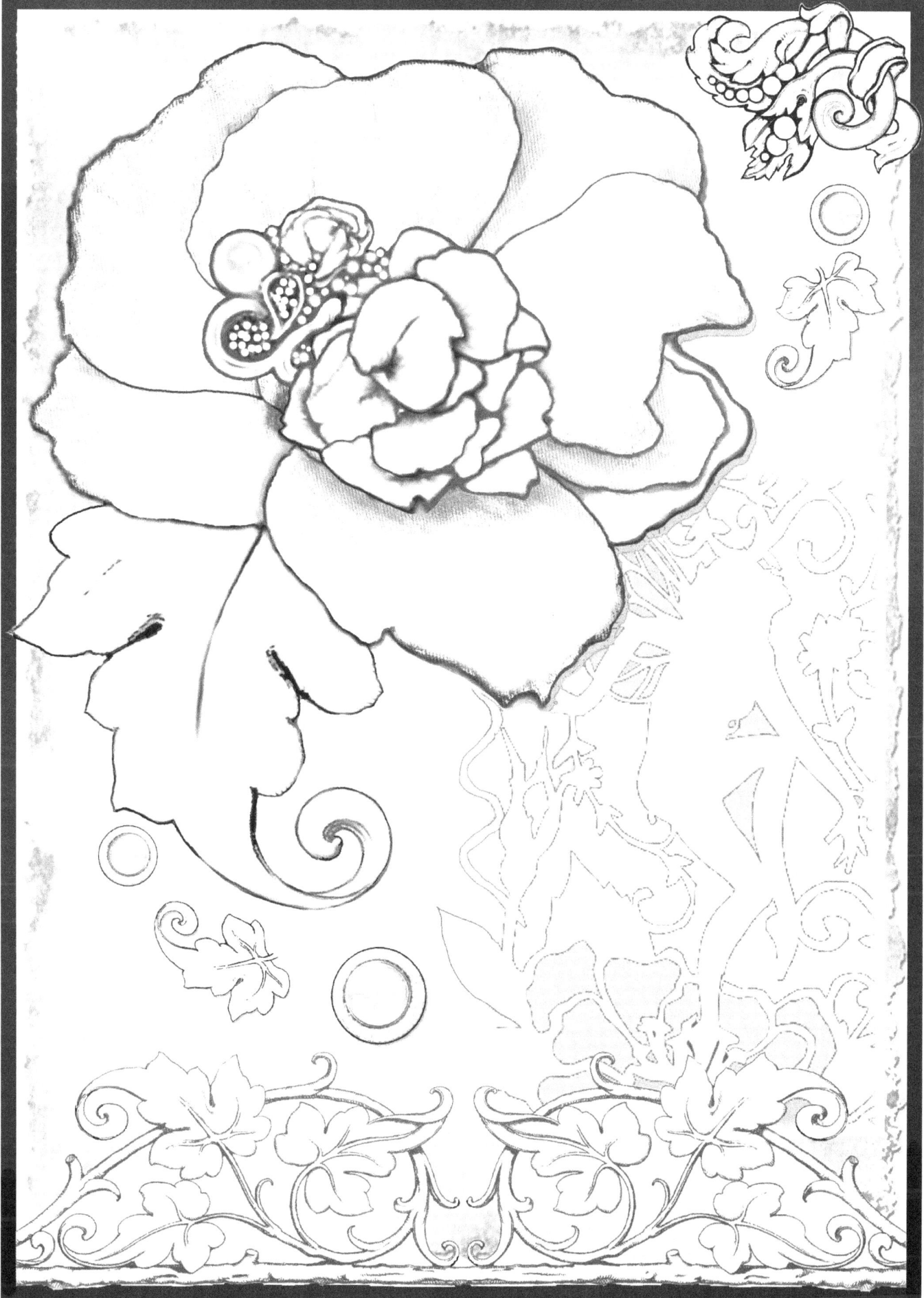

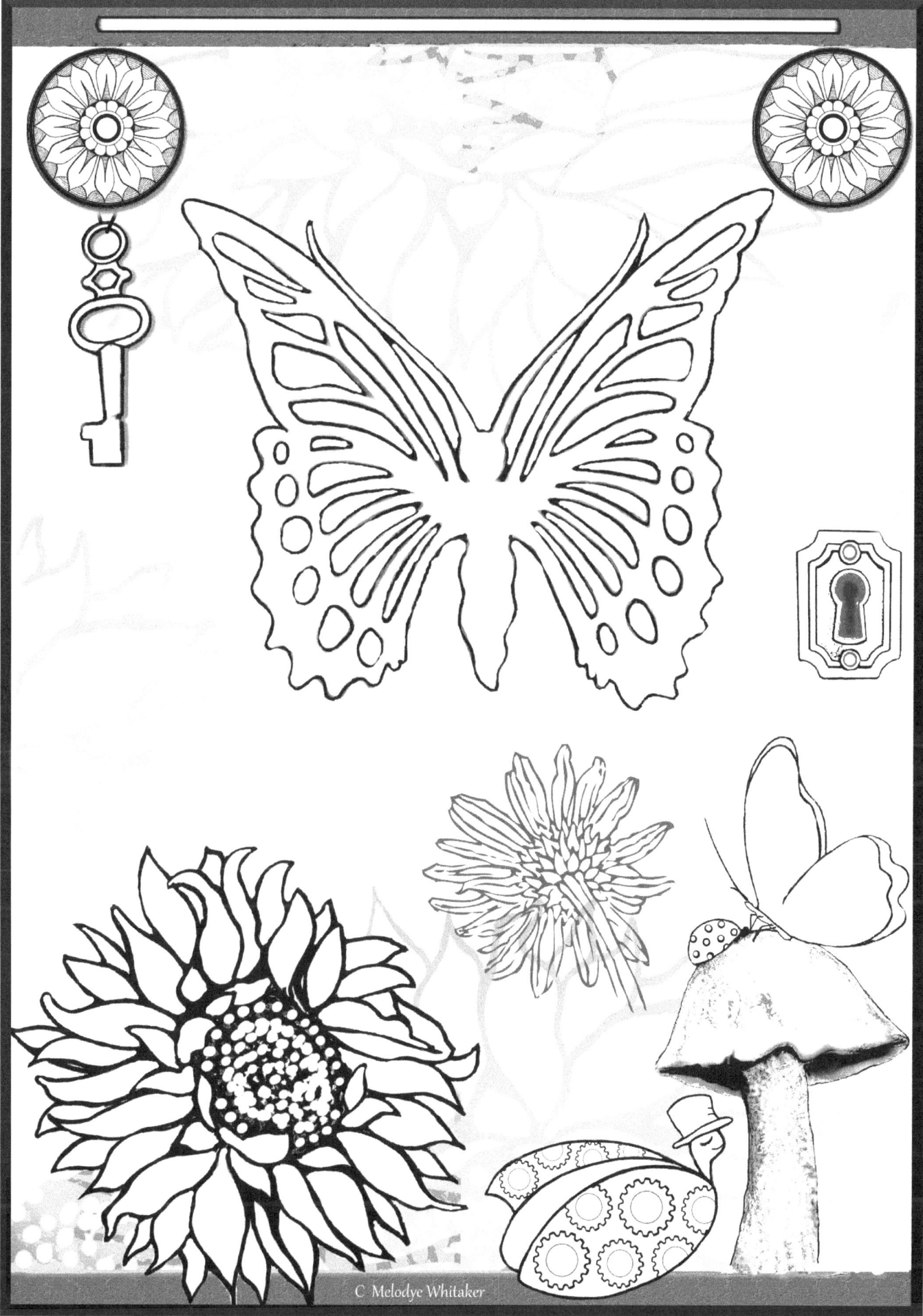

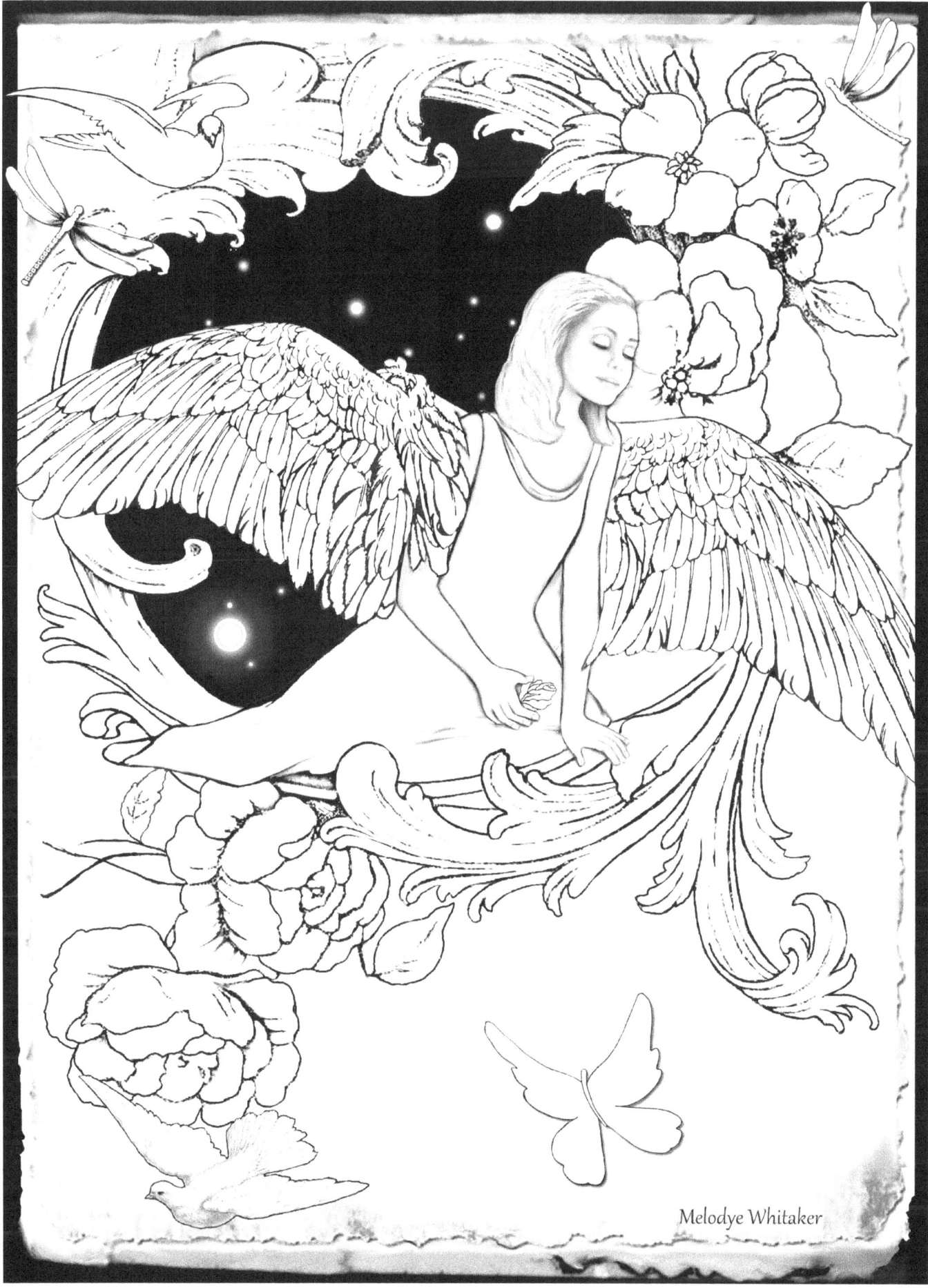

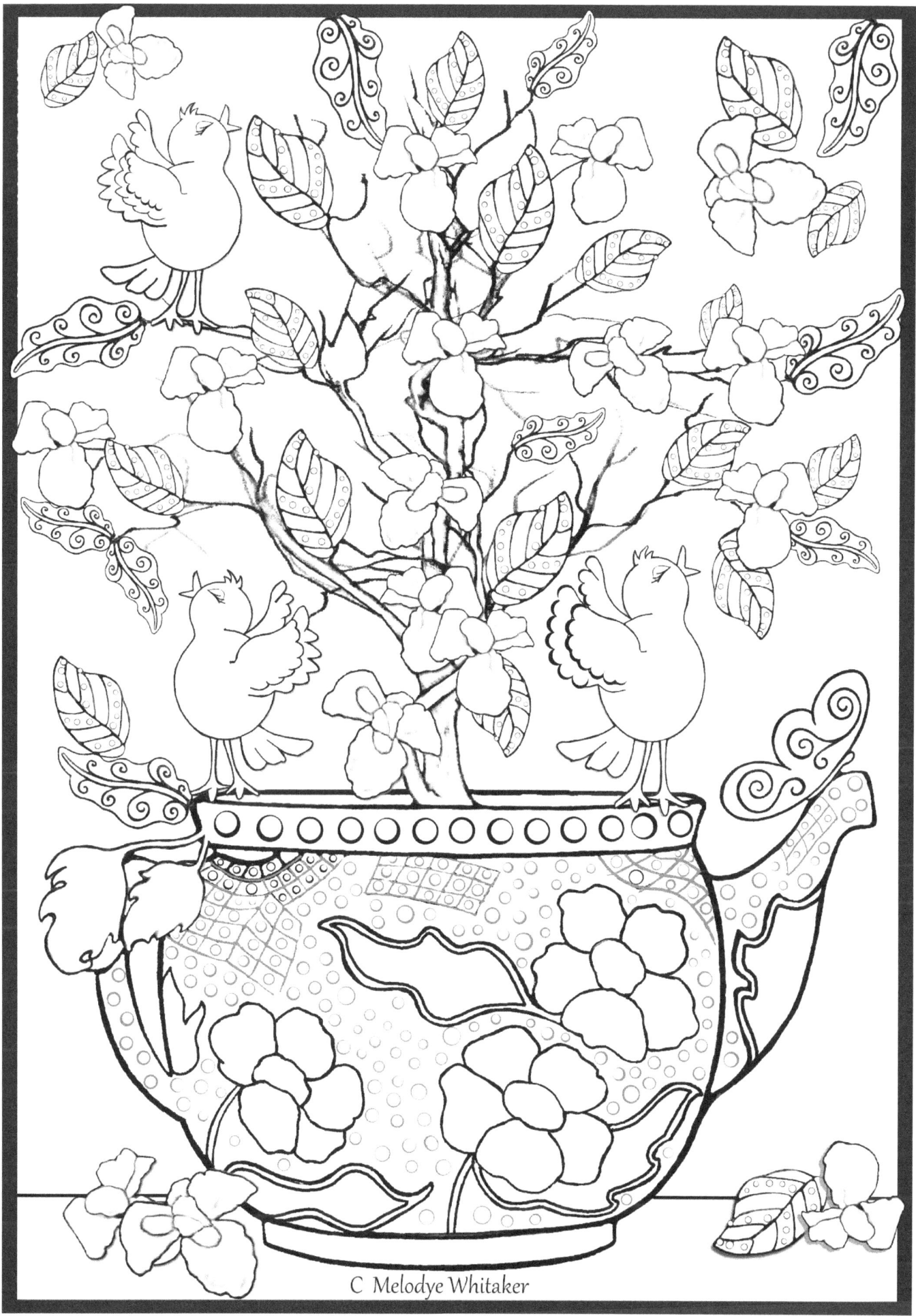

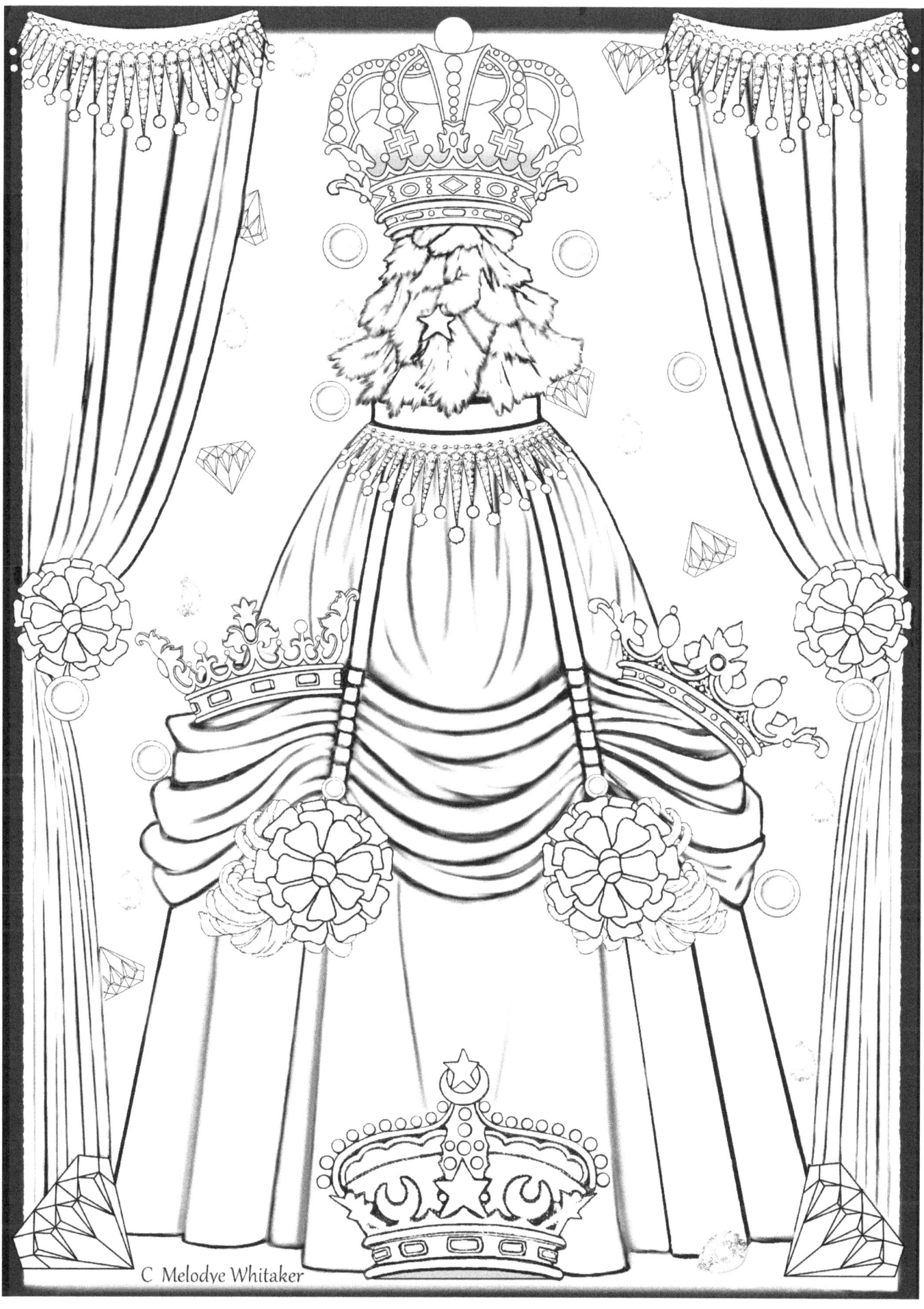

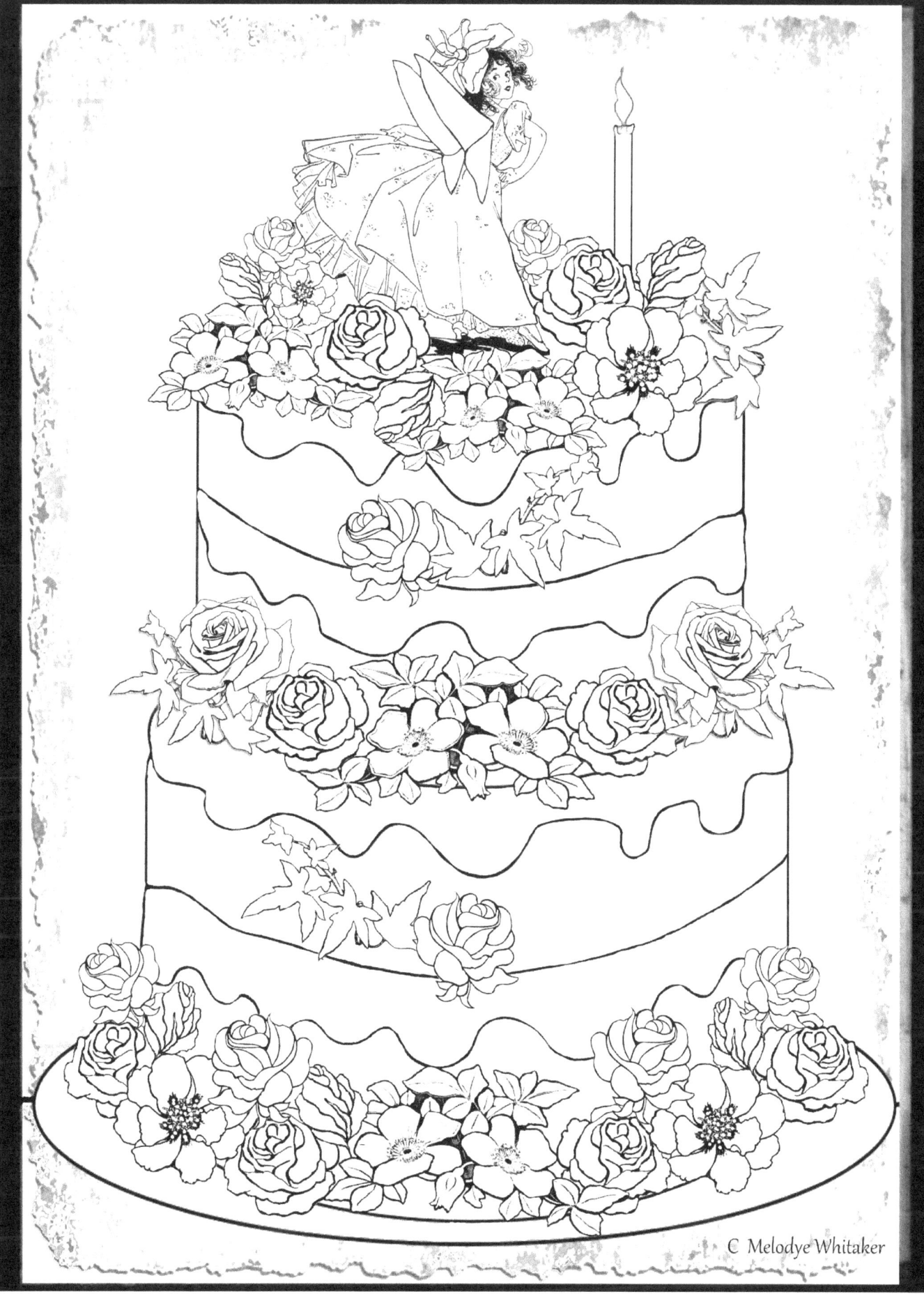
© Melodye Whitaker

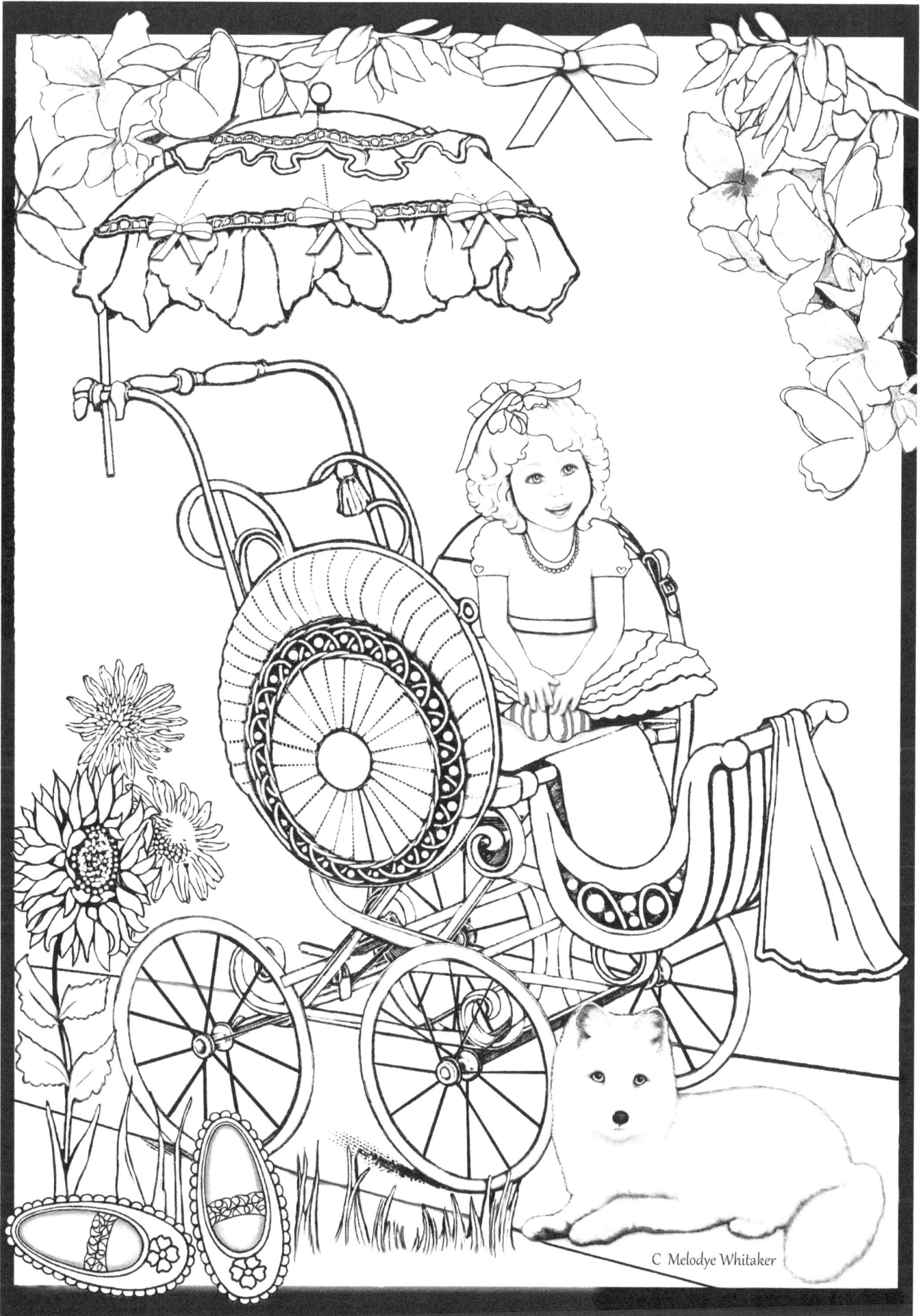

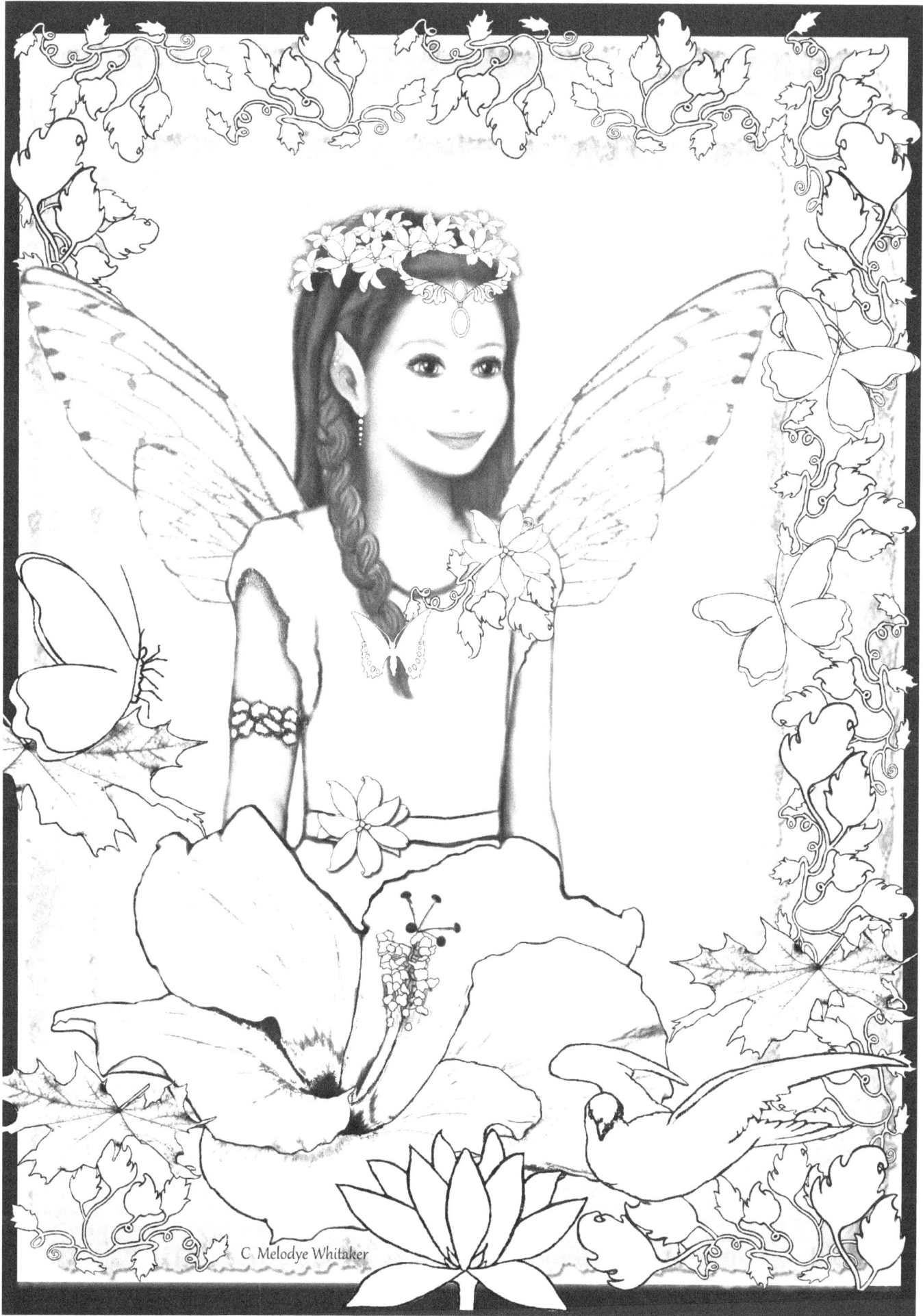

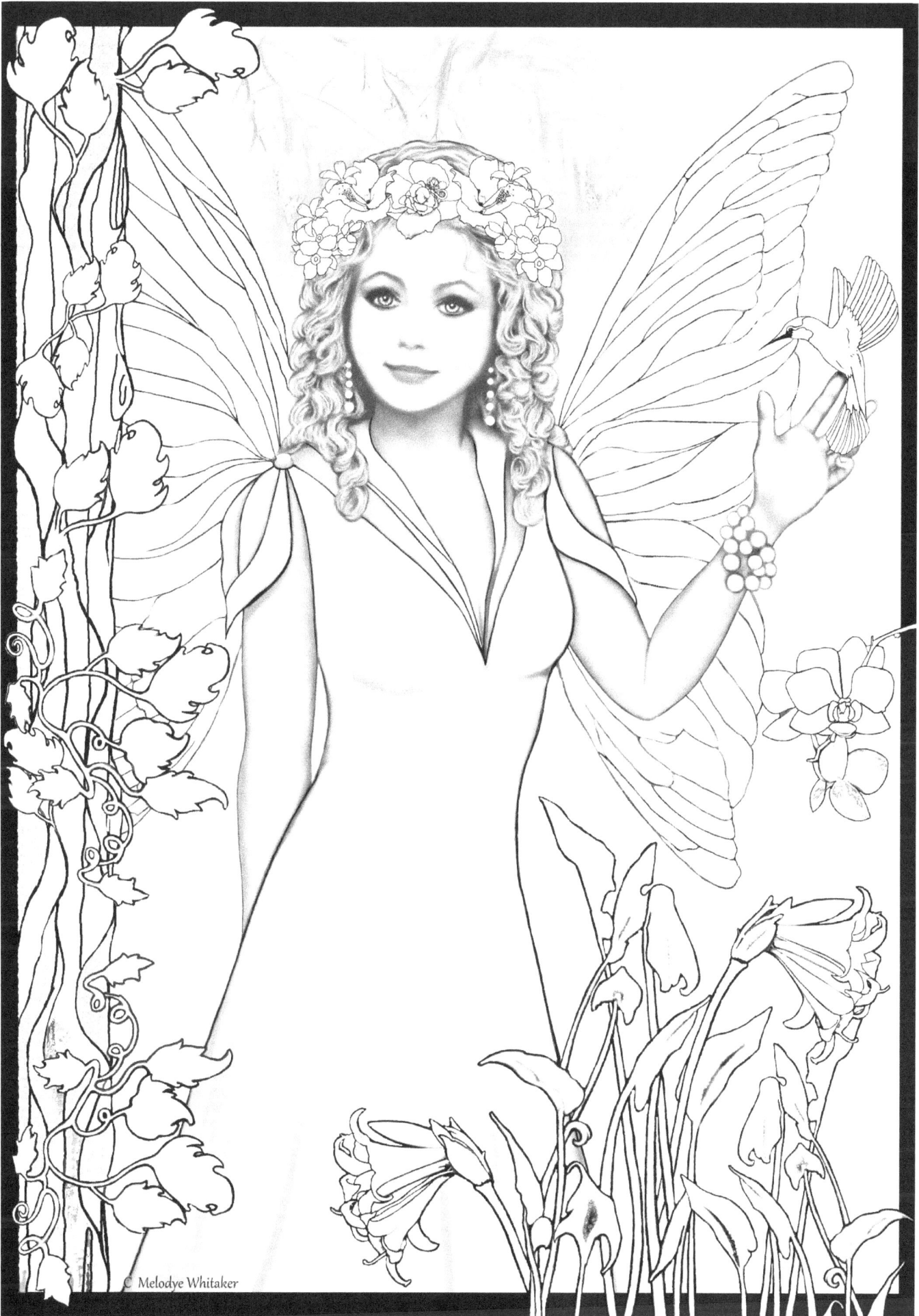

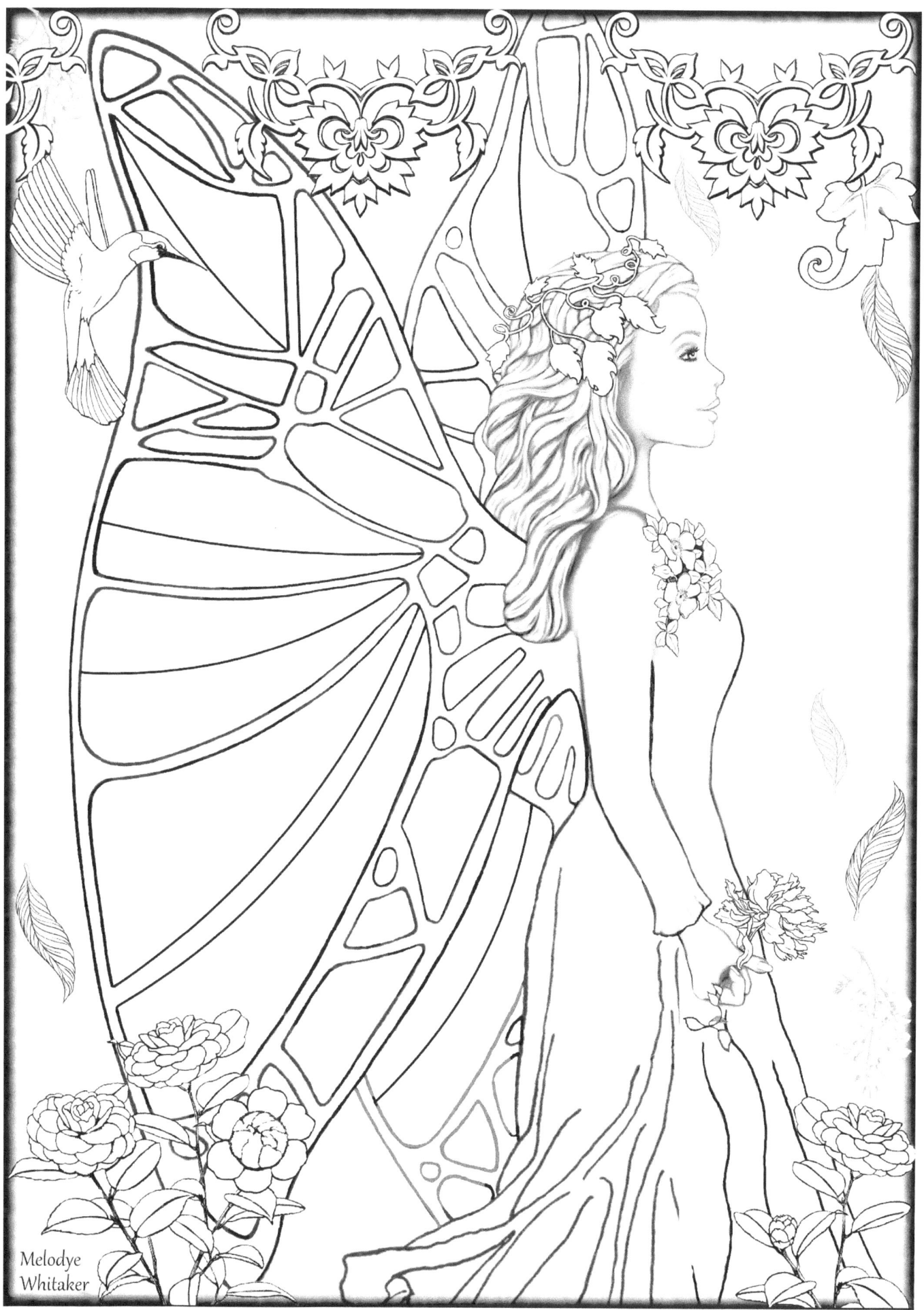

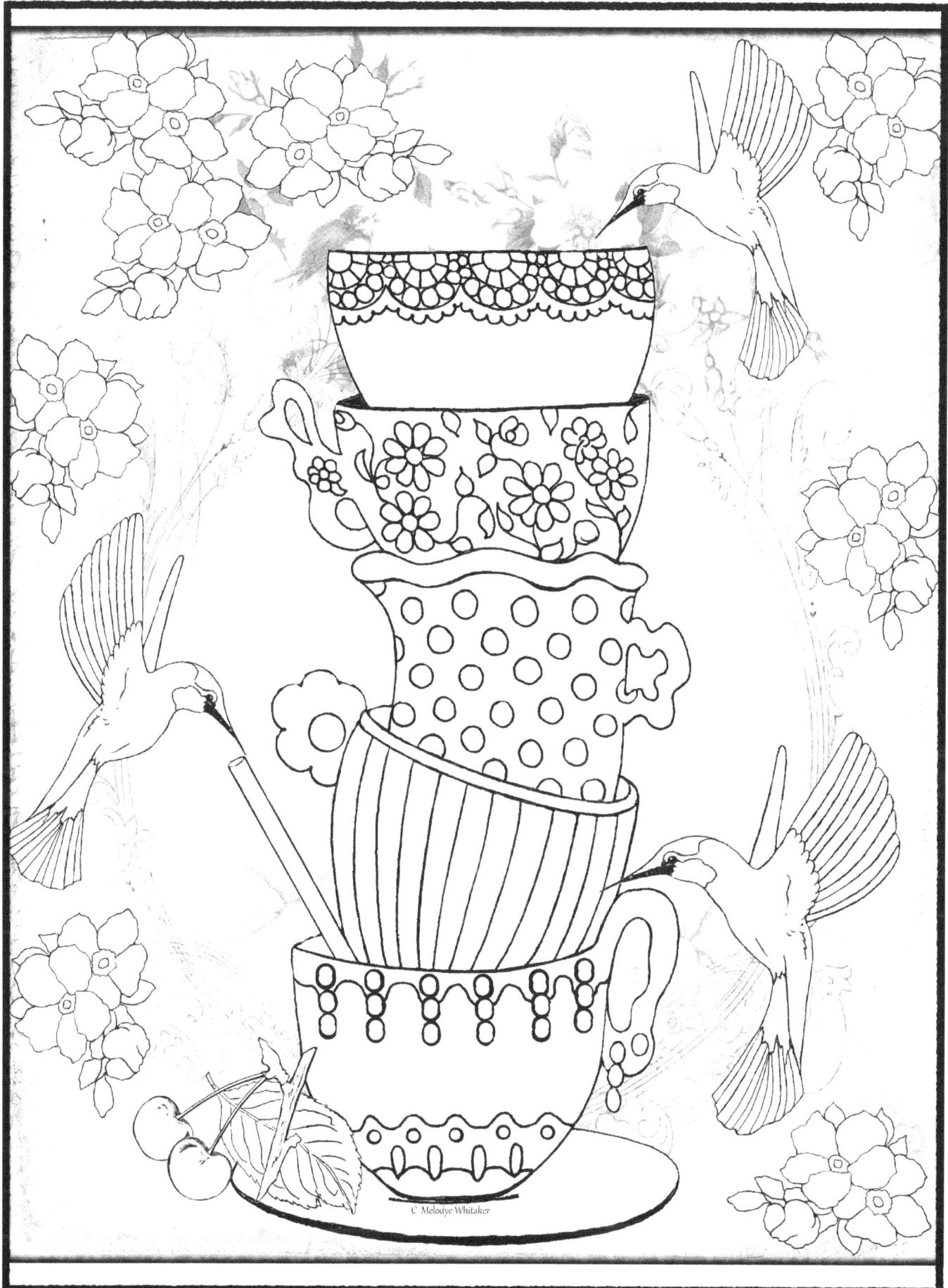

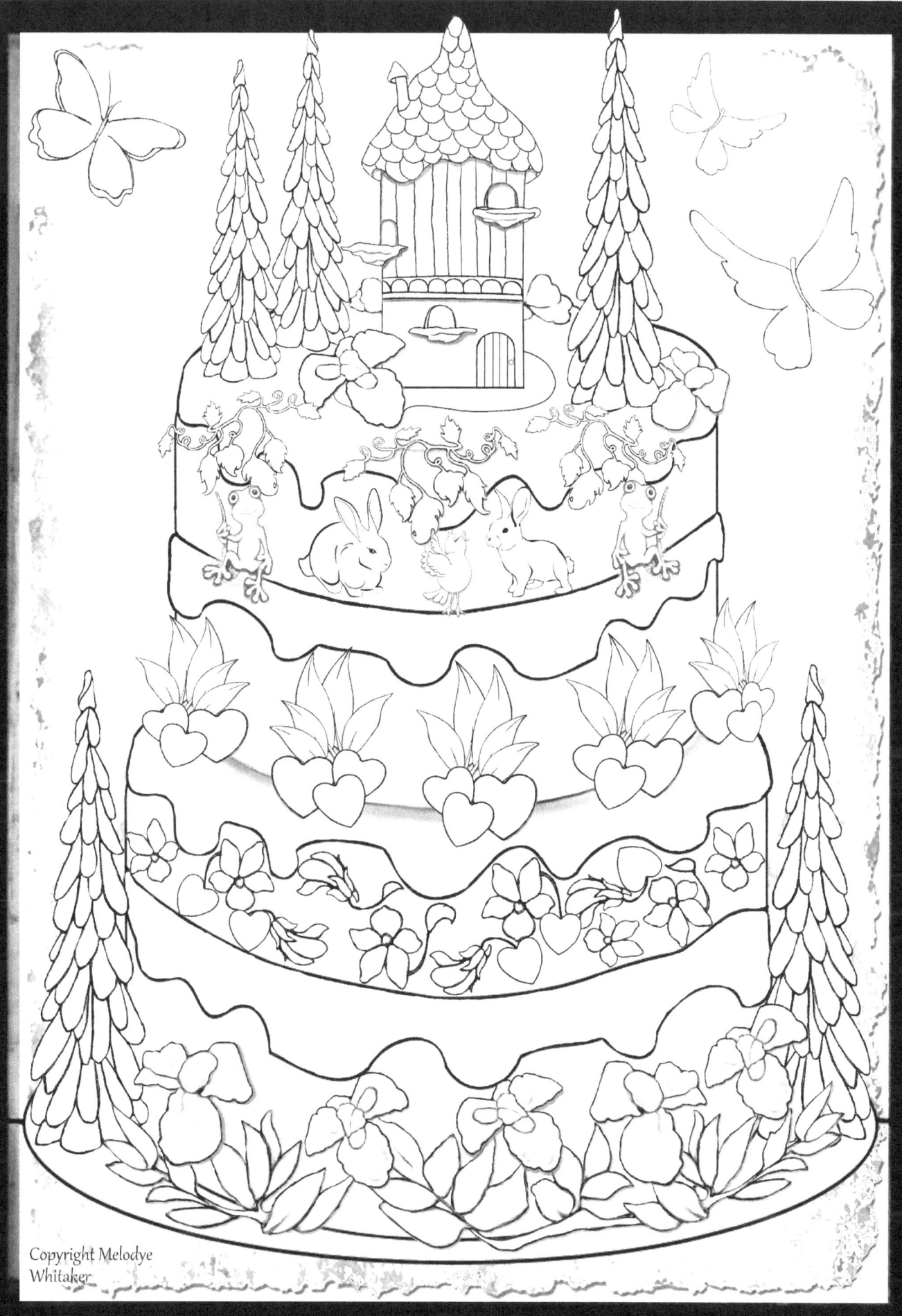

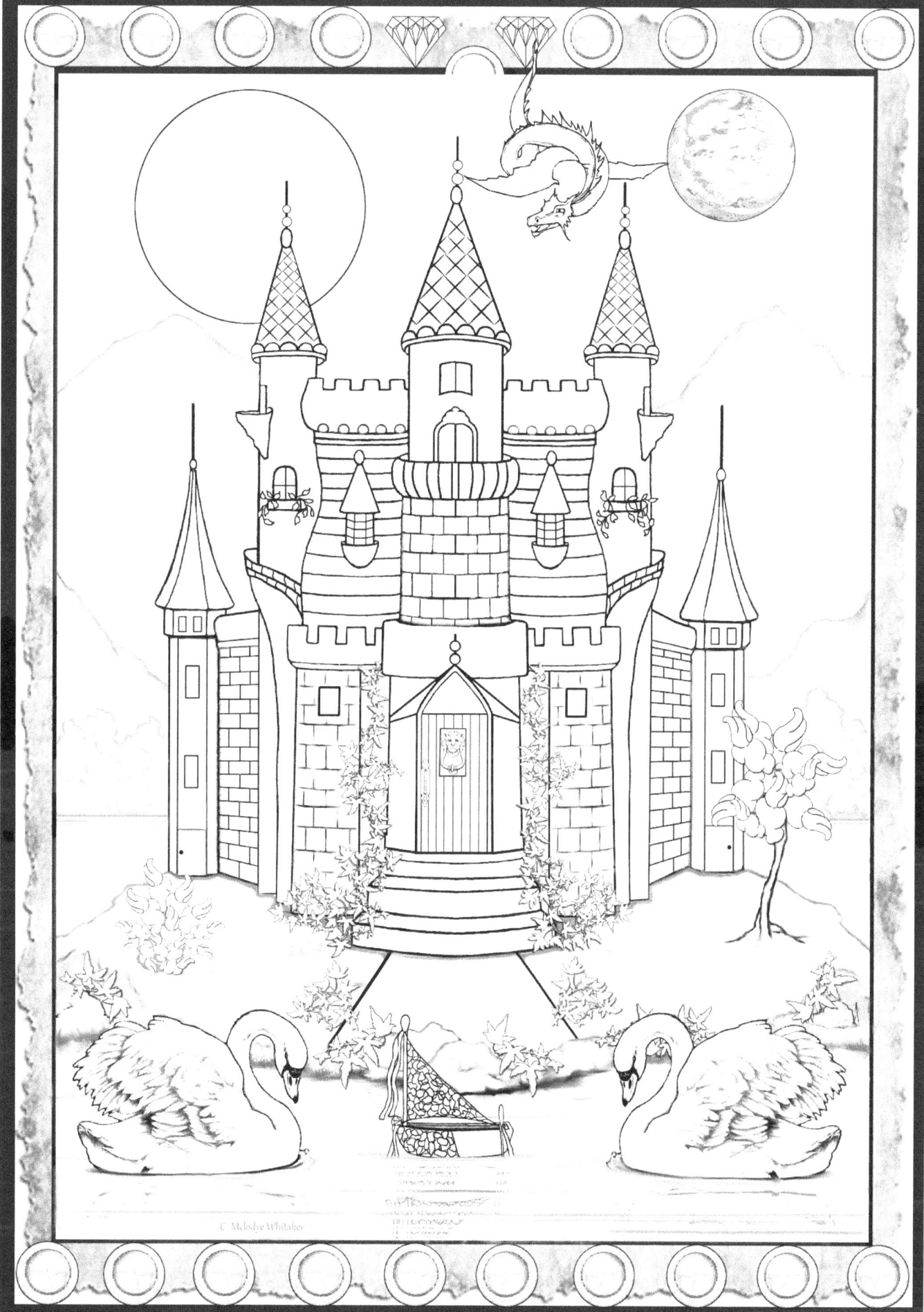

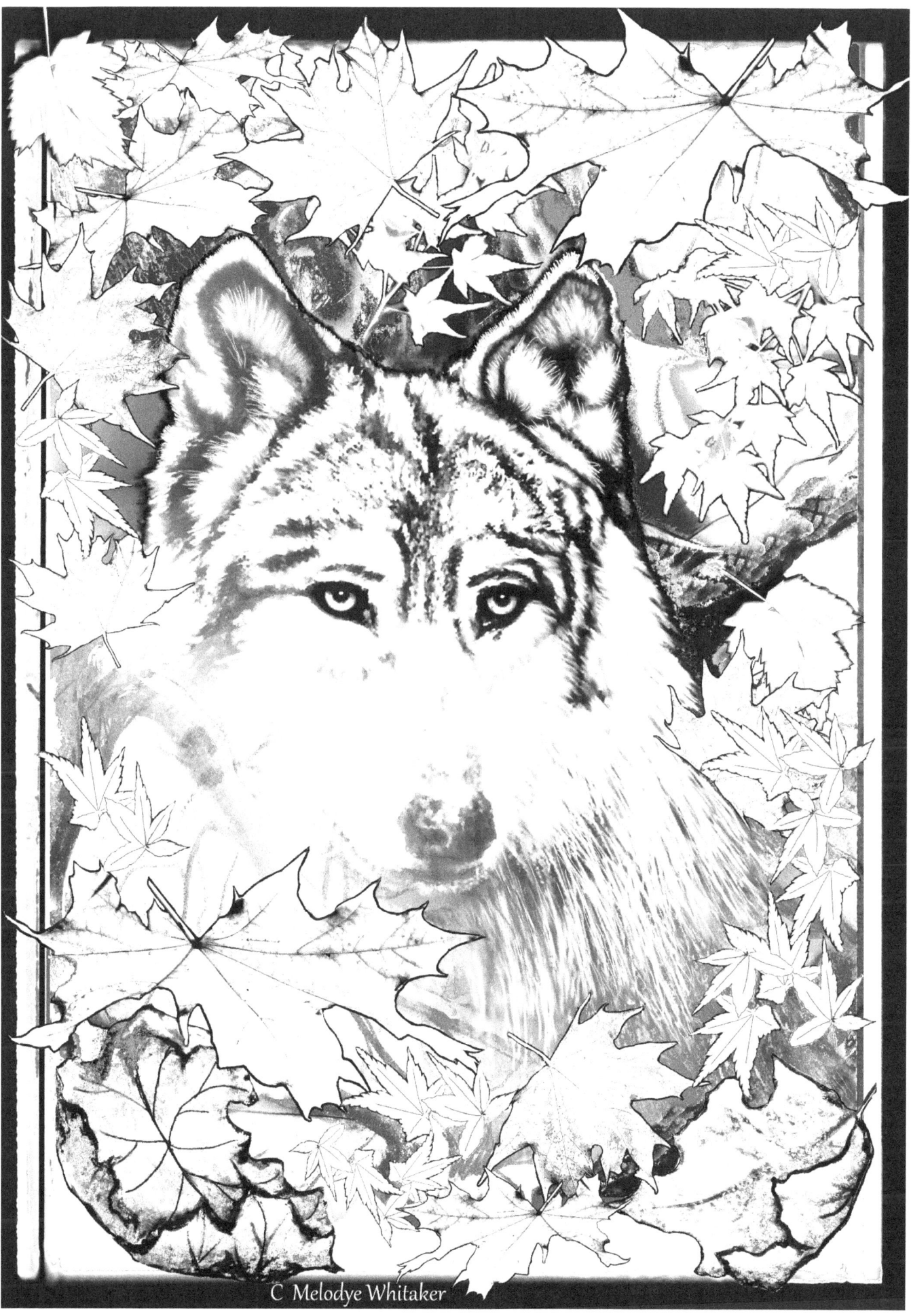

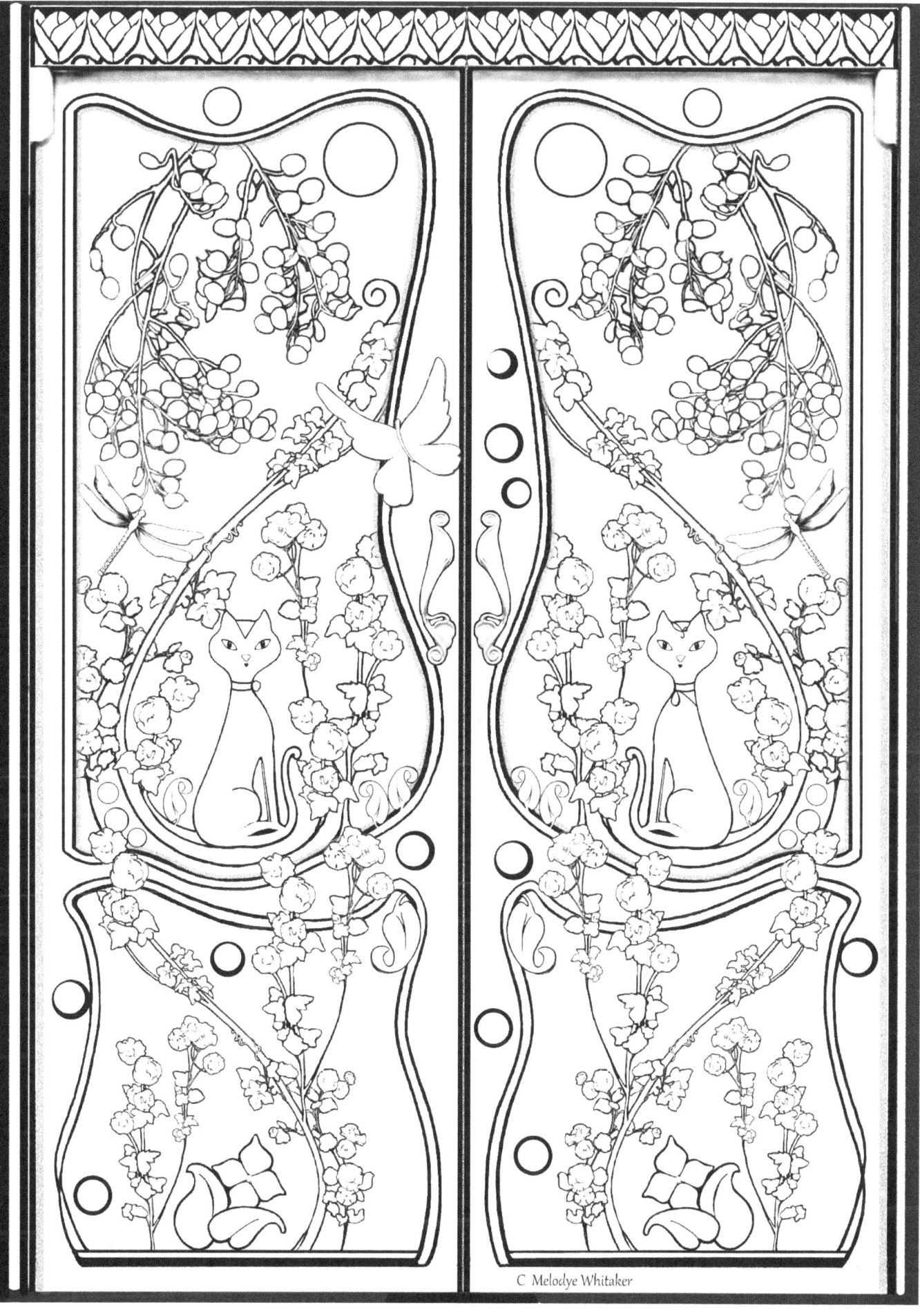
© Melodye Whitaker

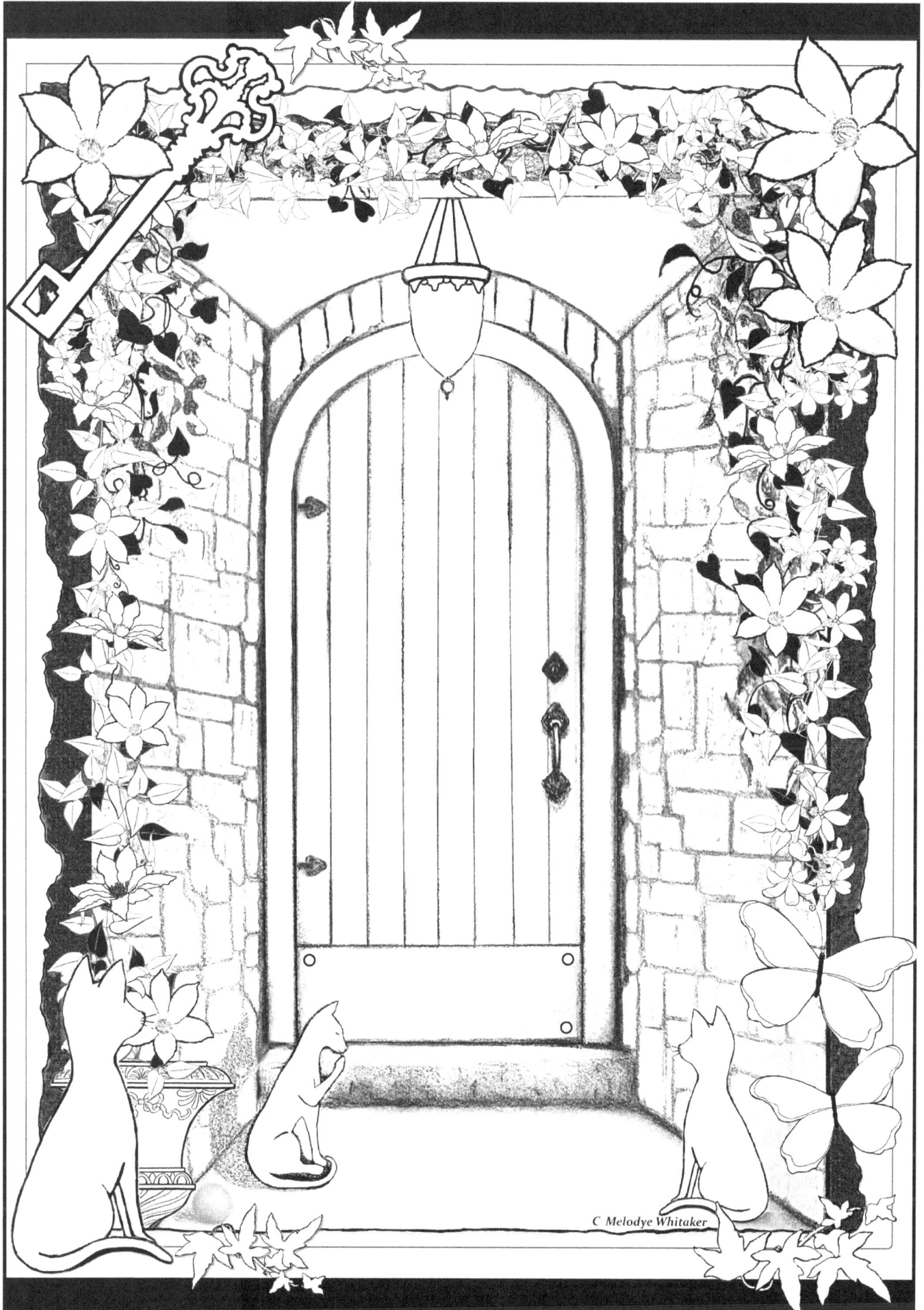

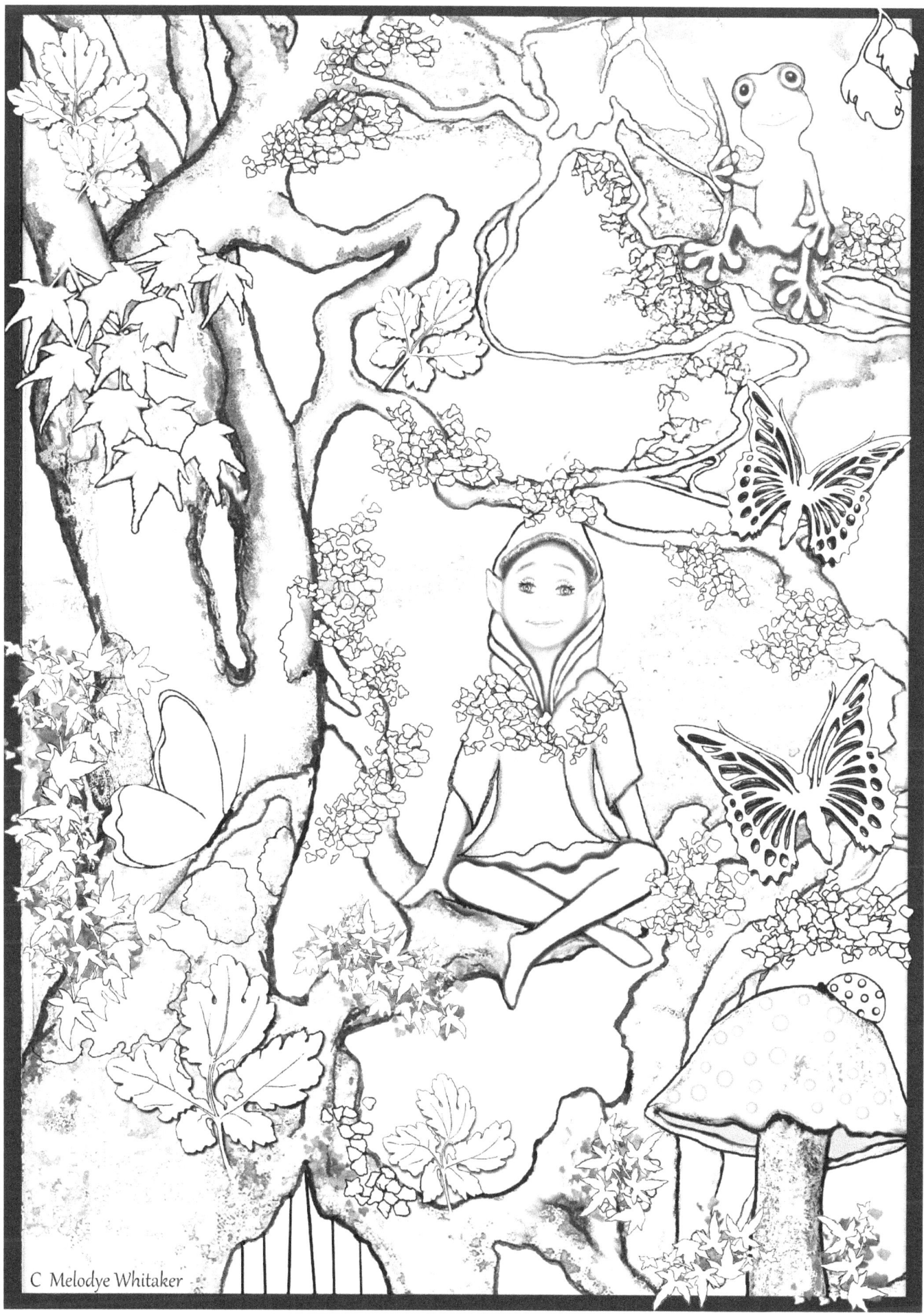

www.ingramcontent.com/pod-product-compliance
Lightning Source LLC
Chambersburg PA
CBHW080712190526
45169CB00006B/2351